PHOENIX

Black Dog Publishing

PHOENIX
ARCHITECTURE/ART/REGENERATION

CONTENTS

PHOENIX INITIATIVE – A CITY REBORN

JOHN MCGUIGAN

In Coventry the symbolism of the Phoenix is very important. Most people will see the Phoenix relating to the devastation and destruction of the city during the Second World War and its re-building thereafter. Whilst this is still an important part of what makes Coventry unique, in recent years the Phoenix ethos has been more directed to recovery from the economic recessions of the late 1970s and 80s, which so devastated what was a boom city.

Each city has to decide what it wants to be. In Coventry, we are trying to make that very direct connection between "where we've come from" and "where we are going to". As a city that has spanned the centuries and played such a key part in British history, we want to understand and appreciate our past in cultural and social terms, but we also want to build a future that recognises the very different world we face now and will face in years to come.

So the Phoenix Initiative was not a random name for a random building scheme within the city centre! The Phoenix scheme is a flagship within a whole process of positive change that is now five years into a £4 billion programme of investment and regeneration.

The challenge to our design team was daunting. Here was a city that wanted to see and feel the manifestation of positive change. Here was a largely derelict and run-down area of the city centre that had been forgotten. Here was a story of 1,000 years of Coventry's history that needed to be told – but in a way that directed us to the future as well as the past. Here was a site that challenged the architects in terms of its geography, archaeology – and on top of that we had to deal with compulsory purchase, road closures, public controversy, etc.. All of the ingredients that make for an inner city regeneration scheme!

As part of our drive to improve the city for the future, the City Council has put significant emphasis upon the quality of urban design and the living environment. In the city centre this is manifested in many different ways – including public art, architecture, urban design and our award winning approaches to architectural and spectacle lighting. Responding to all the challenges that the scheme threw at them, the design team have demonstrated that real spirit of the Phoenix. Their vision, integrity of implementation, emphasis upon quality, tenacity to deliver over what is now a seven year period, all demonstrate the key attributes that respond to the ethos of the Phoenix.

The Phoenix Initiative has delivered exactly what we set out to deliver. It has united and connected key elements within the city centre; it has re-established the ancient topography of the city; it has rediscovered our very rich past but given a very clear manifestation of our very positive future. It is truly a regeneration scheme where artists, architects and other professionals have applied their imagination and skill to positively impact upon the lives of people and their future.

INTRODUCTION
RICHARD MACCORMAC AND VIVIEN LOVELL

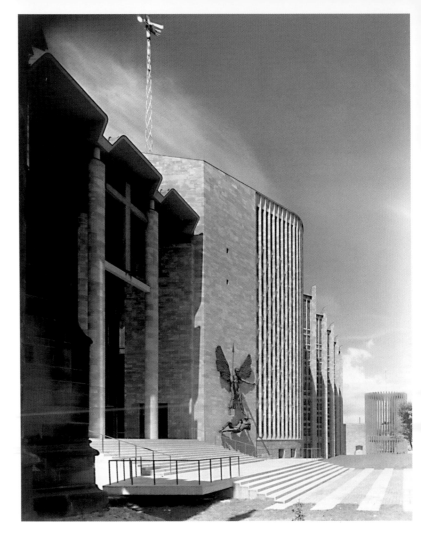

There has been a great resurgence of belief in urbanism and in recovering the idea of democratised public space following a political period in which there was disbelief in planning policy, community and even in society itself. For MacCormac Jamieson Prichard (MJP), the invitation to enter the competition for masterplanning the Phoenix was an opportunity to realise ideas about the public character of cities and ways in which they can be reclaimed for their citizens.

This revived sense of the value of the public domain has given architects a new imperative, an obligation to make places, not just buildings. There has been a similar shift in the perception of public art. The concept of public art as public space (as opposed to the Art in Public Places schemes of the 1970s) was one that Vivien Lovell had been researching through precedents in Europe and in the United States since the early 1980s, and had begun to put into practice through Public Art Commissions Agency's (PACA) work.[1]

MJP, like most architectural practices of their generation, had not originally contemplated working with artists. An important watershed event was the conference on Art and Architecture held at London's Institute of Contemporary Art in April 1982, where Richard MacCormac and Lovell were first introduced. They kept in touch, Lovell occasionally advising on artists' exhibitions at MJP's offices. However, the turning point came when MacCormac gave a somewhat sceptical paper about public art at the British-American Arts Association Conference in Glasgow in 1988, and Lovell challenged him about his lack of collaboration with artists. This eventually led to MJP's collaboration with Lovell on the

award-winning scheme for St John's Garden Quadrangle, Oxford, 1991 to 1993, and subsequently on the Phoenix.

The inception of the project was the city's initiative to regenerate three hectares of the city, an area, which had, in a sense, been lost and abandoned to car parks, traffic intersections and ugly service areas. The task was to reclaim it while paying careful attention to the history of the site.

The aim was to create a collaborative process not just between design professionals, but uniquely to invite artists to make a new place – or series of linked places – redeeming a fragmented site. Through artists' interventions, disparate areas could be given identity, but not by some grand formal gesture, rather by way of an episodic journey through a series of places, highly contemporary yet informed by history, and unique to Coventry.

The team had as its inspiration firstly the original "Phoenix at Coventry" – Basil Spence's splendid account of the building of the new cathedral and his concurrent commissioning of artists; a powerfully symbolic image of the new cathedral is the West Window by John Hutton, which reflects the ruins of the old amidst soaring angels. Secondly, there was the significance of the first pedestrian precinct of the 1950s, by Donald Gibson, with its integrated artworks by Walter Ritchie and others.

Lovell proposed that the Phoenix Public Art Strategy's underlying theme was 'communication'; social, spiritual, physical and industrial,

Opposite: Coventry
Cathedral, 1962. Architect:
Sir Basil Spence and
Partners. Sculptor: Jacob
Epstein. Photo H Snoeck.
Courtesy British Architectural
Library, RIBA, London. ©
Royal Institute of British
Architects.

Above: Coventry Cathedral:
West window of Spence's
Coventry Cathedral,
reflecting ruins.

within the context of reconciliation. The site, blitzed during the
Second World War and subsequently further damaged by the crude
intervention of the 1960s, needed healing. A belief in the power
of art to connect and to reconcile, also the desire to introduce the
anti-monumental, led to Lovell's invitation to Jochen Gerz, a German
artist based in Paris and known for his counter-monuments against
racism and fascism, to be the first artist to present his work and
make a proposal for the site. Gerz's own family home in Berlin had
been blitzed by the British and his baby sister killed in the attack.
To mark the significance of Gerz's work in Coventry and in Britain,
an essay by Sarah Wilson focusing solely on his work has been
commissioned for this publication.

The Phoenix Public Art Strategy outlined the vision, curatorial
objectives, programme overview and selection procedures, from
which MacCormac and Lovell, in conjunction with landscape
architects and urban designers Rummey Design Associates (RDA),
developed a generic brief for artists, having first analysed the site as
different interconnected areas that might act as starting points.
PACA had already carried out some background research on the
writing, topography, archaeology and industries of the area, as they
were concurrently developing a full Public Art Strategy for Coventry
City as a whole. Before the formal artist selection process began a
workshop was organised in Coventry for the architects and several
artists under consideration, to test ideas, walk the site, and
brainstorm in the summer of 1997. In the event two artists, Pierre
Vivant (who ultimately did not work on the project) and David Ward,
took part in the workshop, which started at the cathedral, explored

the views from the 1960s multi-storey car park (which the artists
knew was due for demolition), and proceeded on down through the
site (the Hippodrome was similarly condemned). The site 'ended'
with Lady Herbert's Garden and the ring road – the latter popular with
artists and the subject of proposed art interventions in the concurrent
Coventry City Centre Public Art Strategy.

The artist selection was an iterative process, starting with a curatorial
approach, outlined in the Strategy, a flexible framework from which
to research short-lists of artists and informed by the scope offered
by the site. 'Millennial' and site-related starting points – time, place,
light, commemoration, interaction – led to a commissioning strategy
with scope for artists to respond through the creation of light,
sculpture, sound, landscape design and poetry. Finessing this creative
ferment down into firm commissions – an exciting, intricate and
occasionally painful process – started with several pre-selection
sessions between the art consultants, MJP and RDA. Some
competitive presentations by artists were held prior to the
commissioned design stage to test the potential synergy between
artists and architects. Two excellent proposals, by Bill Culbert and
Mark Pimlott, were not taken forward for various reasons, but are
illustrated in this publication.

The artists short-listed for the selection process were prompted by
the ongoing urban design process for the Phoenix, largely dictated
by the physical and historic characteristics of the site, with its strange
shape and pinch point created by Sainsbury's supermarket, which
was originally expected to relocate. The varying sequence of

Phoenix Workshop with architects, artists and art consultant, summer 1997. Photo Vivien Lovell.

contrasting spaces as they evolved began to suggest ways in which the collaborations with artists would be a series of site specific shared processes, thereby integrating the artists' works fully into the fabric of the project.

These selection processes were developed into full consultations with Coventry's citizens by the formation of a Public Art Selection Panel, which made recommendations to the Coventry Forum. Both bodies were chaired by Councillor John Fletcher, whose intelligence and commitment were a guiding force, as was the leadership of Chris Beck. Representatives from both universities (Coventry and Warwick), the Cathedral, the City Council's Archaeology Department, West Midlands Arts, Arts Council England and a local artist, were invited to be on the panel.[2]

In retrospect, it is almost impossible to chart simply the order of decisions and invitations, which built up the narrative journey from the old precinct through a sequence of new spaces. Various selection procedures were held: an open call for regional artists, an invited competition for Priory Cloister, competitive interviews for Priory Place, Millennium Place, the Garden of International Friendship and the artist's lighting commission. Jochen Gerz was given an open brief. A proposal was invited from the poet David Morley; his subsequent commission involved re-writing the Coventry Carols and Mystery Plays with local communities. Chris Browne's work in the remnants of the old Priory reflects her residency with the City's Archaeology Department. David Ward's artwork *Here*, eight sound posts in the centre of the cloister, takes extracts from the oral archive

creating 'whispering trees' amongst the pleached limes. Susanna Heron's *Waterwindow* introduces the new Priory Place, the sound and site of the water reflecting the animated character of the space. Each of these works is related to, and nurtures, historic connections so that each gives a new interpretation of Coventry's past.

Although the Visitors' Centre was always part of the brief for the project there was a period during the course of the design when no other new buildings were financed. So, for a crucial period MJP and RDA had to imagine and design places without buildings and even considered containing the new places with hoardings and temporary art works.

But eventually the urban quality and commitment to ideas about public art as public space precipitated a sense of value which triggered inward investment and the confidence of private developers. The largest new space, and one of the most crucial collaborations, was Millennium Place and Françoise Schein's *Time Zone Clock*, referencing the city's clock-making past and mapping Coventry's twin cities.

Millennium Place presented further potential for artistic collaborations. Jochen Gerz's *Public Bench*, an inherent element of the space, is now 'blitzed' with a random rash of bright red vinyl plaques bearing pairs of names. Gerz's work has enabled this part of Coventry to be thoroughly appropriated by the public.

Gerz's other work, *Future Monument*, was the most controversial. It is to Coventry's credit that his proposal was accepted, although the

Above: Bill Culbert, *Line of Light*, 1998, unrealised proposal for the Phoenix Initiative. Photo Bill Culbert.

Below: Mark Pimlott, *Volgograd Place*, 1998, unrealised proposal for the Phoenix Initiative. Photo Mark Pimlott.

project was cancelled after the events of 9.11 before being reinstated. Finally, there is the overhead journey to the Garden of International Friendship, via the dramatic spiral ramp and bridge with balustrades by Alexander Beleschenko, necessitated by the need to traverse the old city wall. Dominating the garden is Kate Whiteford's huge maze fragment which seems to emerge from under the ring road. An inscription selected by the poet David Morley adds a narrative element to this contemplative new place.

The collaborations between architect, artists, art consultant, urban designer and landscape architect required extraordinary open-mindedness, trust and a shared belief across the whole team. That it has been so effective in remapping and regenerating part of the city is a result of the successful relationship between art, architecture and landscape.

TIME FOR REGENERATION
ROBERT RUMMEY

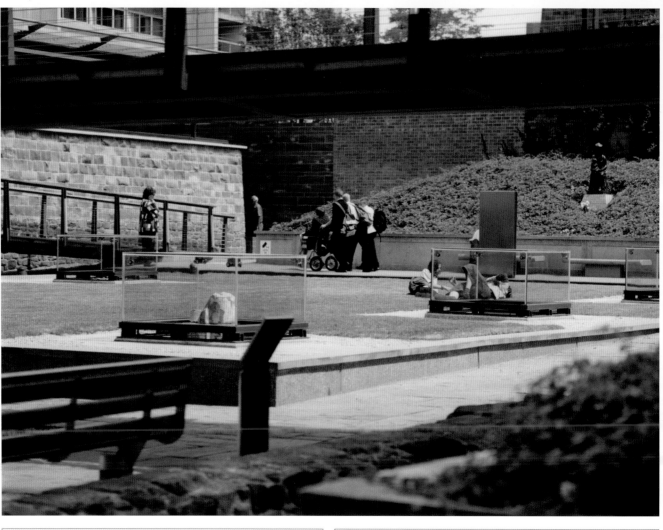

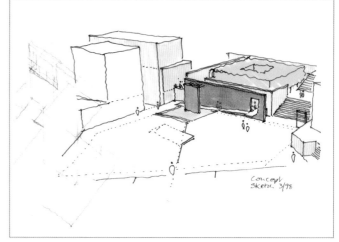

Above: RDA with Chris Browne, Priory Garden, 1998, view from the southwest. Photo Brian Osborne.

Below: RDA, Sketch proposals for the 'Threshold Wall' between Priory Cloister and Priory Place, 1998.

Coventry has a rich history going back to before the fourteenth century when it was one of the wealthiest towns in Britain, famous for its Mystery Plays. But sadly, since the Second World War, with the demise of the manufacturing industry, its past had become smothered by poor buildings designed for expediency.

The City Council seized the opportunity of the Millennium to raise aspirations, using the Phoenix Initiative to rediscover its heritage, reconnect the city centre with its hinterland and apply investment creatively for regeneration. At the time, comparatively few people lived in the city centre; there was little to do there; the site had become a 'ghost town', abandoned to redundant industry, multi-storey car parks and a bingo hall. However, the site earmarked for the Phoenix was strategically placed, bridging the gap between the remnants of the historic and ecclesiastical past, (recently celebrated by Sir Basil Spence's cathedral), and the modern commercial and transport-dominated land to the north.

The Phoenix Initiative aimed to address these problems, the demolition of the multi-storey car parks and closure of a major traffic interchange symbolising the new priorities. It was to be a place for people rather than cars, with a scale, mix of uses and richness of experience that would attract people back to live, relax and commune within the city centre.

The scheme embraces architecture; it is enriched by art, but the overall vision for the project was the physical and cultural regeneration of the city centre. The project forged new connections – in space, with new routes and views opening up the rest of the city – in time, by reflecting the city's past in the new spaces both literally through archaeology and metaphorically through artistic collaborations – and socially by creating places that would bring people together. 'Time' for Coventry has always been important; the city was the centre of the watch-making industry, and recent archeological finds revealed the multi-layered nature of this site. But this was a Millennium project, which needed to look forward, as well as back,

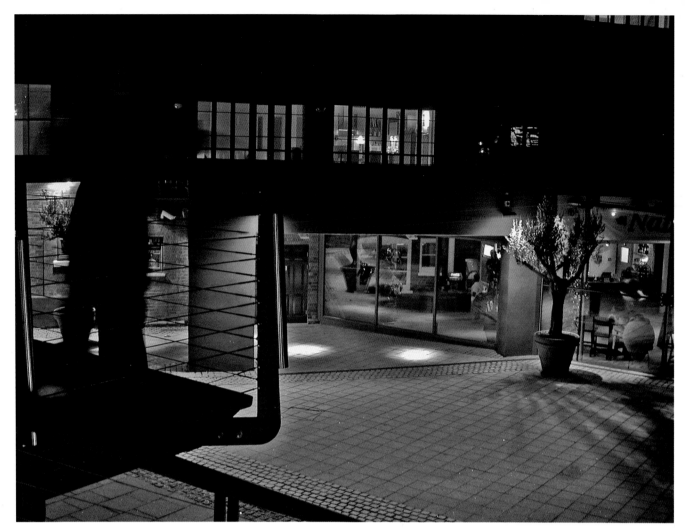

Above: View of courtyard between the Ribbon Factory and Priory Cloister. Photo Michael Rummey.

Below: RDA, Sketch proposals for Millennium Place, 1998.

and which aimed to satisfy the aspirations of today. Indeed, we needed to help shape these aspirations.

A narrative developed that drew together the various themes we identified as being part of the Phoenix. The route from Priory Garden to the Garden of International Friendship was seen as a journey through time – from the 1,000 year history of the Priory, to the ever changing present embodied in the civic events that take place in Millennium Place, to the hope for the future represented in the Garden of International Friendship.

Each space along this journey has a unique character reflecting its own position and role within the city, but linked by the recurring themes of time, memory, reconciliation, and citizenship that are found in the landscape, art and architecture of each space. Light is an important linking theme defining and enhancing the principal route whilst revealing a new drama at night to ensure dynamic, exciting and safe places to visit at the end of the day. The scheme includes

quiet, contemplative spaces to get away from the bustle of the nearby shopping, and stimulating spaces which take our breath away as we enter them. The journey is linked to direct pedestrian routes and accessible by public transport, essential to its success.

This was not all about the creation of new spaces. In fact we took the opportunity to incorporate existing hidden courtyards to create venues for cafes and apartments on a smaller scale. The conservation of the former Ribbon Factory was an important part of the project because it added another layer of time (and industrial heritage) to the project. It is a pity that there were not more buildings to be re-used.

The Garden of International Friendship is a contrast to the other spaces. But again, it is a quiet place, characterised by powerful earthworks and dramatic new walls reflecting the nearby medieval city walls, turning its back on the ring road and facing the sun. This space doesn't just contain art; it *is* art at a large scale:

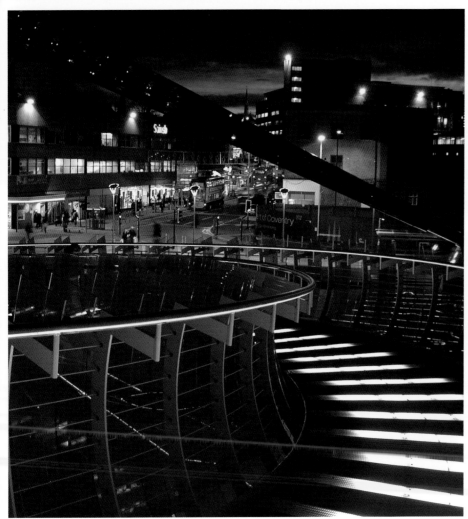

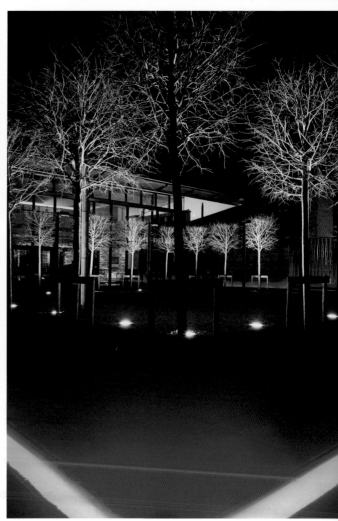

Left: Millennium Place at night from the spiral ramp. Photo Michael Rummey, RDA.

Right: RDA, MJP, with David Ward, Priory Cloister, 2000; with lighting by Speirs and Major following Ward's design. Photo Mandy Reynolds.

best appreciated from the commanding position the glass bridge offers against the dramatic backdrop of the three spires illuminated at night.

The Phoenix has already started to work. There is new investment in homes and businesses on the site. Millennium Place is becoming a landmark for the city, and with the impending development of adjacent sites it will become a more enclosed and intense urban square. New initiatives are extending the vibrant urbanism of the Phoenix into the surrounding hinterland. This is the nature of regeneration. We are designing for tomorrow as well as today.

Fundamental to the project's success is an approach to urban regeneration that is based on understanding rather than preconceived notions. This was an intense collaboration between designers, architects, artists, art consultant and informed client, transport planners and other professionals with a vision to make the city centre used again, to act as a catalyst to further regeneration, and to create a series of 'places' of which Coventry could be proud.

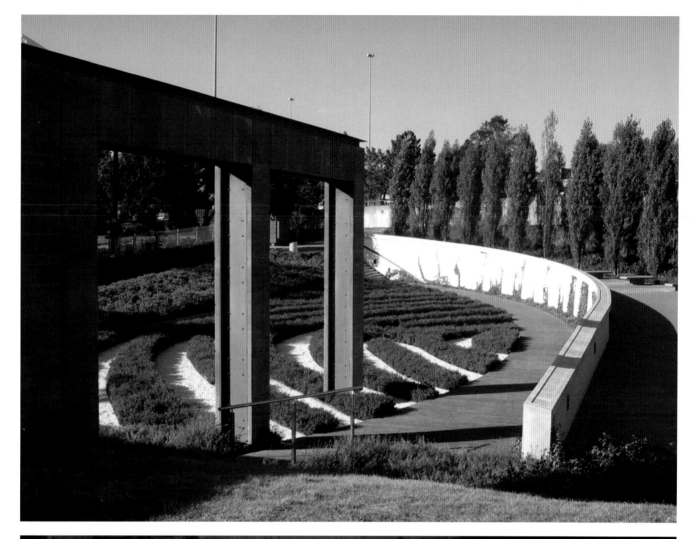

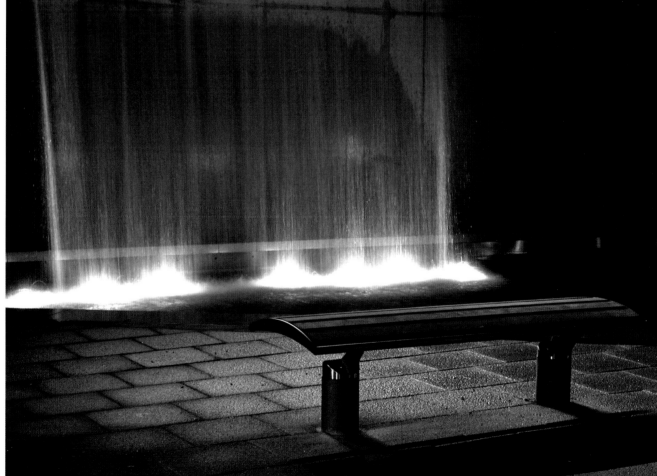

Above: Frame Wall in the Garden of International Friendship. Photo Michael Rummey, RDA.

Below: Susanna Heron with RDA, *Waterwindow*, detail, 2003: view of pool at night. Photo Michael Rummey, RDA.

THE PHOENIX AND THE CITY: WAR, PEACE AND ARCHITECTURE

LOUISE CAMPBELL

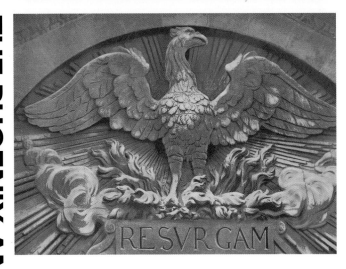

In 1962, the publication of Basil Spence's book *Phoenix at Coventry* linked in the public imagination the emblem of the phoenix with the new cathedral of St Michael, designed to replace its medieval predecessor, gutted during the German air raid on Coventry in November 1940. However, the phoenix (a mythical bird which after 500 years was consumed in flames, and then re-born from the embers) already occupied a significant place in the literature of British post war reconstruction. It featured in Thomas Sharp's town planning tract *Exeter Phoenix* of 1946, and in *Resurgam*, a wartime booklet on planning and architecture, whose cover reproduced the carving of a phoenix rising from the flames placed by Wren over the south portico of St Paul's Cathedral, and which urged support for bold planning in preparation for a "great building renaissance".[1] The phoenix emblem, appropriated in 1946 by Coventry's city architect for use on a stone marking the symbolic centre of the bomb damaged area and the start of redevelopment, simultaneously conveyed both the thrust of civic ambition in his city and the wider dream of recovery from war and national regeneration. Over the next two decades, the Cathedral

increasingly came to epitomise the latter, while the former – less glamorous, more utilitarian, and achieved over a longer timespan – suggested an ideal of civic life which emphasised the creation of new public spaces and the overall quality of the environment, a project in which the entire city rather than any single building within it was conceived as a work of art.[2]

Coventry was regarded in the late 1940s and 50s as a place where growing prosperity, almost full employment, and a young population demanded a city radically re-fashioned and provided with social, cultural and educational amenities.[3] While the promoters of the cathedral scheme hoped to remind citizens of the importance of spiritual values over material prosperity (which, it was correctly anticipated, awaited this city of skilled engineers and machine tool-makers in peacetime), the city architect aspired to create a handsome framework for civic life, a place where local artists' work would take its place alongside that national monument – embellished by international artists – represented by the cathedral, a city where

Opposite: *Resurgam*, detail, St Paul's Cathedral, London. Courtesy Warwick University

Above: Trevor Tennant, *Phoenix carving, The Levelling Stone*, Upper Precinct, 1946. Courtesy University of Warwick Slide and Photograph Library.

local arts and local traditions would be reinvigorated alongside its industries.

The sheer pace of development in the 1960s perhaps took the city's planner-designers by surprise. Prosperity, followed by a rapid reversal in Coventry's fortunes in the late 1970s, meant that the integrity of the city centre's design was compromised by a succession of unsympathetic developments intended to revitalise the commercial centre. The effect was to undermine the ideas underpinning the city plan and to trigger a gradual degradation of the physical environment. The 'city of the future' envisaged in 1945 became by the 1980s a sad place, a place in which modernity had lost its savour. Just as the cathedral was increasingly presented in terms of a gory theatre of war, a place in which to re-live 'the blitz experience', rather than in terms of a twentieth century building, the city also foregrounded its medieval past (and the damage inflicted upon its medieval fabric in 1940) rather than its vibrant modernist legacy.[4] The Phoenix Initiative of 2000, with its emphasis upon memory, stimulates us to approach

the city's history in a less selective way. By merely scratching the surface rather than engaging in deep archaeological excavation, it is possible to recuperate the significance of the post war reconstruction of city and cathedral, both in its own time and for ours.

In 1940, reports of the air raid on Coventry had focussed upon the loss of life among the civilian population ("Coventry – our Guernica" read one headline).[5] Subsequently, however, the raid was discussed in terms less of a crime against humanity than as a crime against the city, symbolised, as in Victor Hugo's *Notre Dame de Paris*, by its cathedral. Distracting attention from the city's armaments and aeroplane industries (something which made it an obvious target), and from the perceived inadequacies of the measures taken to protect its citizens, such reporting represented the raid as a simultaneous attack upon architecture, upon history and upon religion.[6] In the prolonged interregnum between 1940 and the start of reconstruction work in earnest in both cathedral and city, the ruins of the cathedral acquired enormous significance, locally and

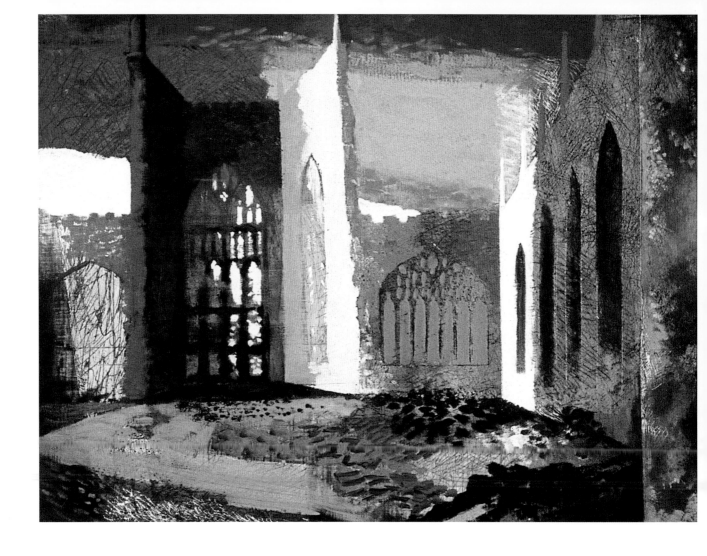

John Piper, *Ruins of Coventry Cathedral*, 1940. Courtesy Herbert Read Art Gallery.

nationally.[7] Drawing upon the prevalent romanticism of contemporary British art, in which painters like John Piper represented bombed churches and the gutted House of Commons as harshly melancholy, highly dramatised theatres of war, the ruins of St Michael's were re-ordered so as to provide a memorial garden, a ceremonial space and an incitement to rebuild. The concept of death and rebirth, re-articulated in terms of the Christian doctrine of sacrifice and resurrection, underpinned the clergy's decision to place in the ruins an altar built of rubble and a cross of charred roof timbers. The same concept coloured their vision of the new cathedral, and informed the brief supplied to the architect.[8]

The idea of preserving ruins as a token of endurance and recovery is an ancient one, although as Collins points out, not one favoured by medieval prelates.[9] In 1948, Le Corbusier produced a design for the bombed French town of St Dié in which, by sheathing the ruins in concrete and glass, he proposed "to make the charred and ruined cathedral a living torch of architecture; to take deferent charge of the misfortunes which have struck it, and make it a perpetual witness of the tragic event for the rest of time. The roof has fallen in, and the choir and transepts… allow through their jagged shreds of red stone a glimpse of mountains and the waving foliage of great trees…."[10] Effects comparable to that planned for St Dié (where by sheathing the ruins in concrete and glass, Le Corbusier aimed to produce a "quivering symphony of stone and of souvenirs") were achieved by incorporating war-damaged structures into new churches all over Europe – at Düren, St-Lo, Ronchamp, and Cologne, where the new Gürzenich encompassed fragments of St Alban's church and Kathe Köllwitz' sculpted group of *Mourning Parents*. At Coventry, Spence, responding to his brief, proposed a slightly different solution which by removing the rubble altar and timber cross into the new building, and linking the ruins to the new cathedral by means of a porch and a retractable glass screen, suggested a spatial continuum between the two. Although the details were to be slightly modified, the concept of the new building growing from the old underpinned the design of Spence's cathedral, whose dominant perspective leads the eye to

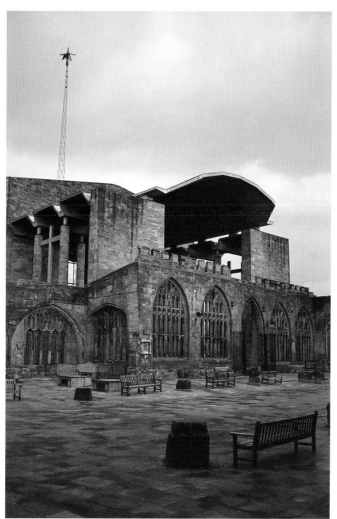

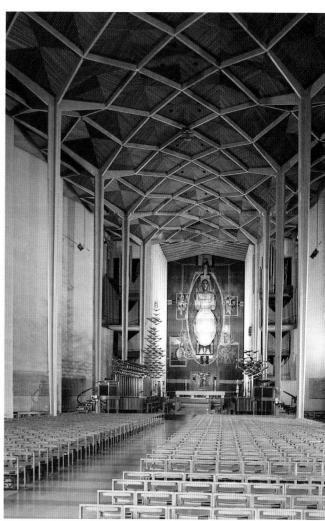

Left: Coventry Cathedral, from nave of St Michael's. Courtesy Warwick University.

Right: Coventry Cathedral, Interior. General view, towards alter. Courtesy University of Warwick Slide Library and Photograph Library.

the image of the risen Christ, forcefully reminding viewers of the message of salvation central to Christian doctrine, while by means of a series of subtle references and reformulations, the building was integrated with the architectural and liturgical traditions of the Anglican church.[11] The iconography of the new cathedral's tapestry, sculpture and glass, reinforcing the themes of life after death, of redemption through suffering, drew on a spectrum of images, both secular and religious. Highly pertinent to Coventry's wartime tribulations, they possessed a broader resonance: the figures from Henry Moore's shelter sketchbooks, portal sculpture from Romanesque cathedrals, Sutherland's Northampton *Crucifixion*, photographs of the inmates of Dachau, and a series of painted panels depicting the dead, the burned and the fleeing survivors of Hiroshima which toured Britain in 1955.[12] Spence, who envisaged that the interior be viewed through a screen of bodies, ensured that the gaunt, elongated images of martyred saints and angels which John Hutton engraved upon the glass entrance screen would effectively mediate visitors' experience of the nave, just as the ruins

which served as its forecourt helped to condition their understanding of the new cathedral. The device ensured that suffering was mingled with hope, with the tragic past filtering experience of the present; more significantly, by referring to a repertory of images not exclusively drawn from Christian iconography, it helped establish a common emotional ground which was not confined to those of a particular religious faith.

The translucent entrance screen (and the design of the new cathedral) was closely implicated in the attempt to establish meaningful relationships between the cathedral and the city which was being planned around it. The city architect Donald Gibson, appointed in the wake of the Labour Party's takeover of the Council in 1937, was poised to implement a robust programme of civic improvements. The destruction of large parts of the city centre in 1940 encouraged Gibson to broaden his remit and design a comprehensive redevelopment scheme in which industrial, commercial, civic, educational and cultural buildings were relegated

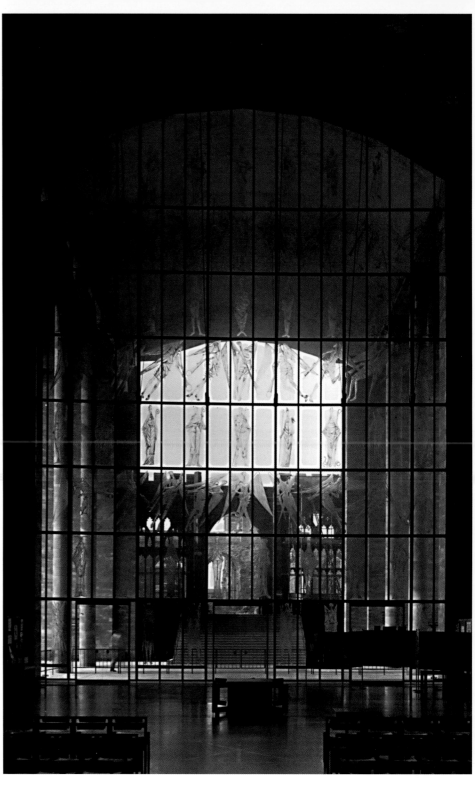

Coventry Cathedral, window by John Hutton. Courtesy University of Warwick Photograph Library. © Alan Watson, University of Warwick.

to separate zones. Despite his rational approach to land-use, Gibson apparently felt that a Corbusian city of towers – in which the commercial centre provided the high-rise heart – was an inappropriate model for Coventry's development.[13] In what after the war was conceived as a low-rise city, the spires of Coventry's two great parish churches and cathedral were planned as the highest points; its centrepiece, a new shopping precinct (replacing the traffic-choked junction of Broadgate and the Burges) was aligned with the tower of St Michael's. In proposing a pre-industrial urban hierarchy, Gibson was encouraged by the wartime Bishop Neville Gorton, anxious to assert the presence of the church in a city with a phenomenal record of recent growth.[14] Interestingly, the Bishop had initially favoured sweeping away the ruined cathedral altogether and replacing it with a huge new one in order to signal the church's modernising intentions. However, persuaded of the arguments for retention, he and the city architect agreed that the ruined cathedral should constitute the organising axis of the Coventry plan, while providing a counter-point to the character of its new buildings in

terms of height, style and location. The placing of the new cathedral at right-angles to the old in Spence's 1951 design represented an almost Baroque piece of urban design in which an ancient right-of-way was reinstated to provide a route between the modern commercial city and its old industrial zone (now earmarked for education) via the grand porch and entrance steps. The glass screen of the cathedral, allowing passers-by views of altar and tapestry within, helped to ensure that the cathedral remained a powerful presence in the new city.

Gibson shared the inter-war planners' enthusiasm for functional zoning and for generously spaced buildings. Coventry's centre was to be transformed by a re-configuration of the road system and by eradicating the city's traditional tight mixture of industry and housing. However, Gibson's designs for the new buildings of the city centre represented a moderate, regional modernism, which was informed by terrain, materials, and local precedent. Sensitive to the effects of architectural scale and grouping, and – in a city of fast-growing car

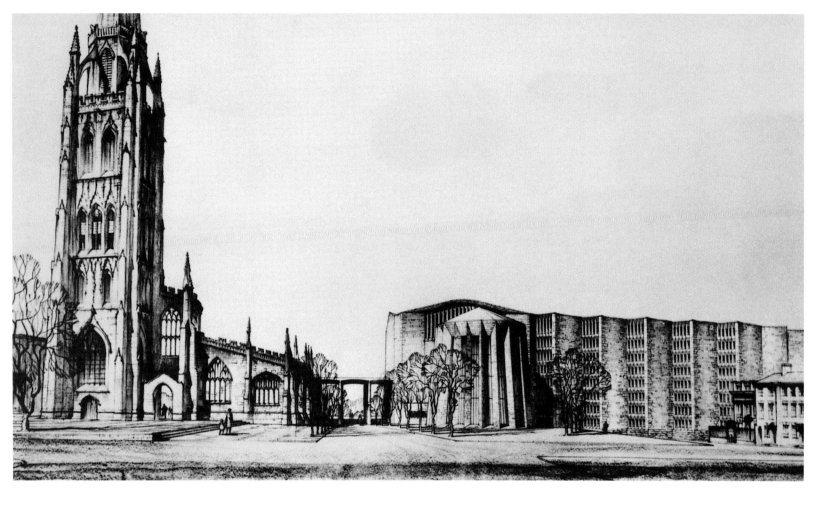

Coventry Cathedral, Perspective from west (drawn by Lawrence Wright), 1951. Courtesy Warwick University.

ownership – to the need to segregate pedestrians from vehicular traffic, Gibson proposed "quiet precincts where the movement of people is slow, and close and intimate" to offset the tempo of busy streets and to compensate for the potential monotony of a rationally planned city.[15] The two-level pedestrian precinct which formed the centrepiece of Gibson's Coventry was, with Rotterdam's Ljnbaan, the first of its type in Europe; the innovatory status of Coventry's Upper Precinct tends to obscure the homely character which red brick, Hornton stone and slate facings gave to the long ranges of shops and flats, suggesting a modern version of a Midland market square.[16]

Gibson stressed the need for "plenty of sculpture and fountains" and planting to provide visual incident and richness for this new environment. He, like Bishop Gorton, hoped that the city would generate art as well as provide a setting for it. Just as the new cathedral was in 1940 conceived as home to "a school of wood-carving and stone-carving and mural painting", the new museum

and art gallery was intended to contain artists' studios as well as collections of historic art.[17]

Gibson's programme of commissioning works of art for the city was driven by the concern to offset the mechanistic culture of the booming post war city with a reminder of more humane values, something inspired by his reading of Lewis Mumford's *The Culture of Cities*, with its condemnation of "the insensate industrial town", a book which circulated widely in both the architect's department and in the Council House during the 1940s. An exceptionally young population which (in the 1950s) included a high proportion of new-comers to the city proved a spur to architectural innovation and to the invention of elaborate civic rituals and iconographies. The sculptor Trevor Tennant, working in a local camouflage unit during the war, carved the phoenix on a butterfly-shaped piece of slate, the Levelling Stone, which was ceremonially placed in 1946 over a casket containing relics of Coventry's historical past. More light-hearted works for the new city centre included the wooden figures

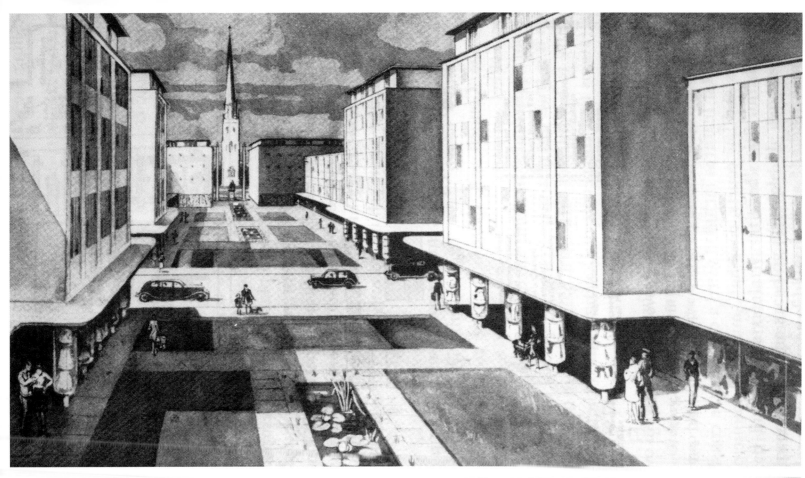

Above: Donald Gibson,
*View of proposed precinct,
Coventry*, from *The Future
of Coventry*, 1945. Courtesy
University of Warwick Slide
and Photograph Library.

Right: View of Upper
Precinct, Coventry. Courtesy
Louise Campbell.

Walter Ritchie, Relief Panel in Upper Precinct, *Man's struggle to control the world inside himself*, Coventry, c. 1951-54.

Following pages: Coventry, 1946. Photo Simmons Aerofilms.

of Lady Godiva and Peeping Tom, carved by Tennant, which appeared on the hour from the ornamental clock incorporated in Broadgate House at the head of the Upper Precinct, and the figures representing the local legend of *Guy and the Dun Cow* carved by Alma Ramsey from Coventry School of Art. In 1955, the local sculptor Walter Ritchie carved a pair of reliefs on the demanding themes of *Man struggling to control the forces inside himself* and *Man struggling to control the forces outside himself*, representing the interaction of nature, culture, religion, and technological progress, positioned under the bridge spanning the Upper Precinct.[18]

Although this ambitious programme did not end with Gibson's departure from Coventry in 1955, the character of the city's architectural development shifted from the homely idiom of the 1950s to embrace a more exuberant and cosmopolitan style. While extending the precinct, his successors Arthur Ling and Terence Gregory abandoned the previous height restriction, using tall blocks to terminate its western, northern and southern arms. The visual cohesion which the vista of St Michael's spire had previously given the precinct disappeared in 1989 when the Cathedral Lanes development engulfed the open space of Broadgate, previously a fulcrum around which the city centre's plan pivoted. In 1962 Mumford, visiting Coventry, criticised the design of the Technical College facing the cathedral steps, suggesting that it indicated a poor relationship between city and cathedral.[19] In 2000, old rivalries – originating in the competition for scarce resources after the war, kept under control by Gibson, but re-igniting after his departure – appeared to reach a new peak in the un-neighbourly ostentation of the re-modelling of this building (now part of Coventry University).

Looking back 50 years at the architecture and public art which were devised for both city and cathedral, the project to confer meaning upon the new environment by endowing it with spaces, focal points and zones of memory, encouraging a sense of place and of identity, appears as an innovation as significant in its own way as the creation of the pedestrian precinct. In mid-century Coventry, by spelling out local histories and by fashioning links between the craft traditions of the medieval city and the prospect of a dynamic future, it was hoped to reconcile its citizens (both long established communities and those who had recently arrived) to the disturbing legacy of wartime, to the privations of the recent past, and to the uncertainties of the future.

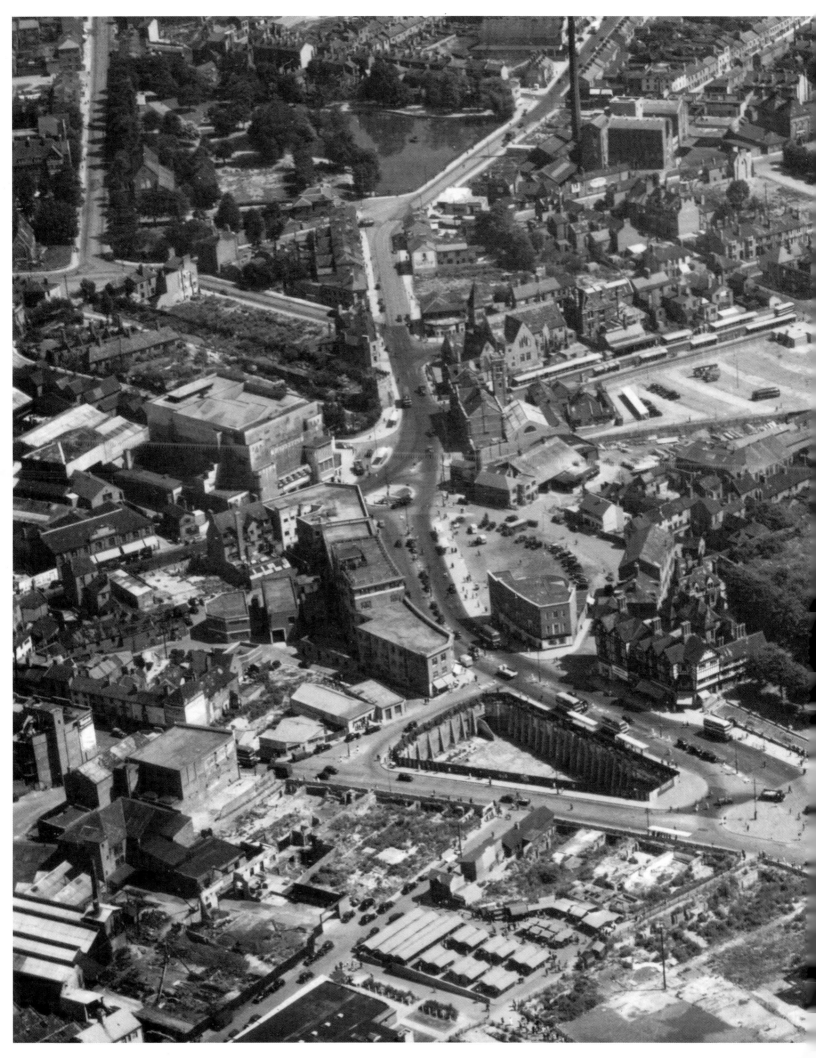

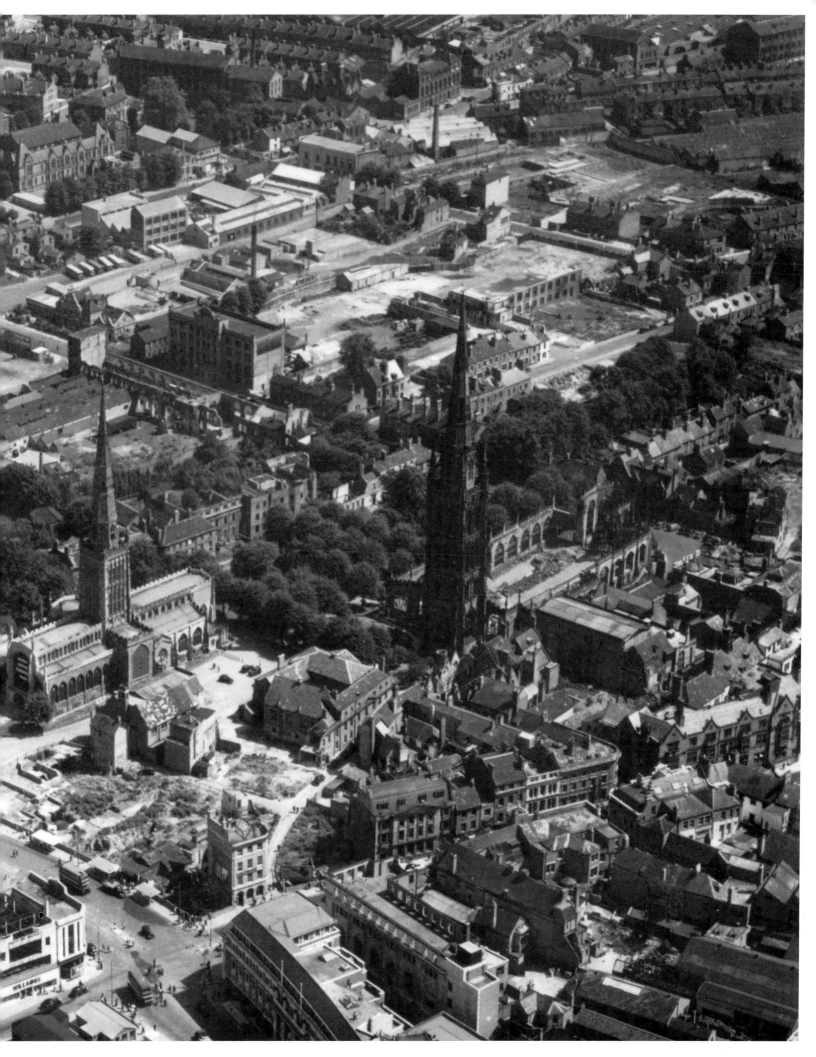

PHOENIX: ARCHITECTURE, ART, REGENERATION
THE JOURNEY

INTRODUCTION

To pass through the portal spanning between the twin basilicas of St Michael's Cathedral Church in Coventry is to experience the essence of modern Coventry. The gutted fifteenth century church resonates with the violence inflicted on Coventry in November 1940, whilst the new cathedral is a testament to the spirit of forgiveness, hope and renewal, the spirit of the Phoenix.

The themes revealed at this stark conjunction between old and new, of reconciliation with the past, belief in the present and faith in the promise of the future are essential to Coventry as a whole and are the foundation of the ideas developed through the Phoenix Initiative. The scheme covers three hectares of Coventry City Centre and was initiated in 1997 to revitalise what had become a rundown part of the city. Funded by Coventry City Council, the Millennium Commission, Heritage Lottery Fund, Advantage West Midlands, and the European Regional Development Fund, the Initiative sought a wholesale redevelopment of the site to create a series of new urban spaces, providing opportunities for public art and public events and for regenerative development of the wider area.

It is a journey of discovery for the interested resident or visitor, defined by interventions, factual and interpretative, visual and aural. Urban design, architecture, landscape, art, archaeology and lighting combine to explore the complexities of the site in search of a response that is appropriate and unique to Coventry.

The focus on public art and collaboration builds upon Coventry's history of commissioning contemporary work, integrating art with architecture by nurturing both innovative work and participation by artists of local, national and international standing. The city has unique qualities: as an ancient centre; its post war building programme, which integrated public artworks; its new cathedral resulting from a brave modernist architectural competition; its car industry and its world class School of Industrial Design. In this way, the public art commissioned throughout the site reflects an underlying theme of communication, emblematic of a city in progressive transition.

In the spirit of The British Sculpture exhibition held in the old cathedral ruins in 1968, the art programme aimed to encourage the artists in collaboration with architect and planners, to assume "the responsibility for summing up and expressing the meaning of the modern city and the human life within it". (Canon Stephen Verney, Coventry Cathedral 1968).

The journey from St Michael's portal reveals the physical topography of the site, by opening views and routes from the high ground of the cathedral precinct of the valley and lost waterways of the River Sherbourne and Radford Brook below. The historical topography is exposed as one passes from the secular and spiritual heart of Coventry, via the lost priory of St Mary's, over and beyond the remaining section of the original city walls. The journey gradually reveals the centre, the boundary and the world beyond the enclosure of the medieval city, terminating with the new Garden of International Friendship.

The Phoenix Initiative was developed in three phases between 1997 and 2003, with a final phase due for completion in 2005.

Opposite: Phoenix, 2004.
Photo MacCormac
Jamieson Prichard.

Right: RDA, *The Journey –
concept sketch*, 1998.

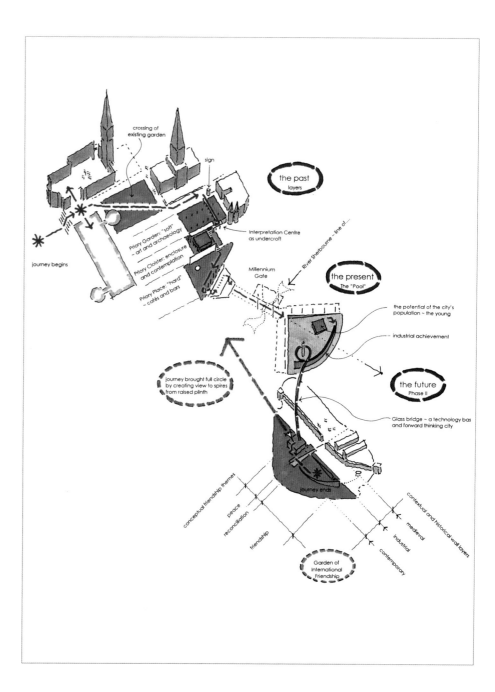

A JOURNEY IN LIGHT
MARK MAJOR AND PHILLIP ROSE

Light plays a vital role in the experience of 'Phoenix'. By day, sunlight provides a constantly changing rhythm of light and shadow, enlivening textures, colours, surfaces, forms and spaces. After dark the lighting of the site transforms it into a different place – with different focus and contrasts – an alternative visual landscape knitted into the heart of the city.

Speirs and Major Associates began their work in Coventry in 1997 when they were approached to prepare a strategic lighting master plan for the city centre. This study provided a radical new approach to lighting in Coventry and one in which the quality of the experience was to be considered as important as the quantity of light employed.

As part of the lighting strategy we identified a series of major interventions within the city centre that were sure to have an impact on the success of 'Coventry after dark'. The Phoenix Initiative was the most important of these in that it represented a unique

opportunity to provide a fully integrated approach to light, architecture and the urban landscape. As a result of our work we were approached to provide a lighting scheme for the project.

The legibility of the site, including the role the various spaces, structures and artworks might play after dark, together with how the lighting might contribute to the safety and security of pedestrians provided the central theme for the design. The hierarchy of the major and minor routes, axial relationships, the development of visual boundaries and the views in and out of the site further informed the overall design process. The scheme aimed to provide a well lit environment without recourse to over-lighting. The aim was to articulate the routes and spaces through the careful lighting of the surfaces, objects, materials and details that defined them.

The lighting in each of the areas of the scheme was designed to provide the variance in character implied by the work of the artists, architects and landscape designers. By example, MJP's Whittle Arch, which is solid and shimmering by day, becomes a semi-

Right: RDA with Chris Browne, Priory Garden, 2001: view at night with lighting by Speirs and Major. Photo Mandy Reynolds.

Opposite left: RDA with Speirs and Major, detail of balustrade lighting. Photo Michael Rummey, RDA.

Opposite right: Speirs and Major, *Lighting Strategy Concept Sketch*, 1999.

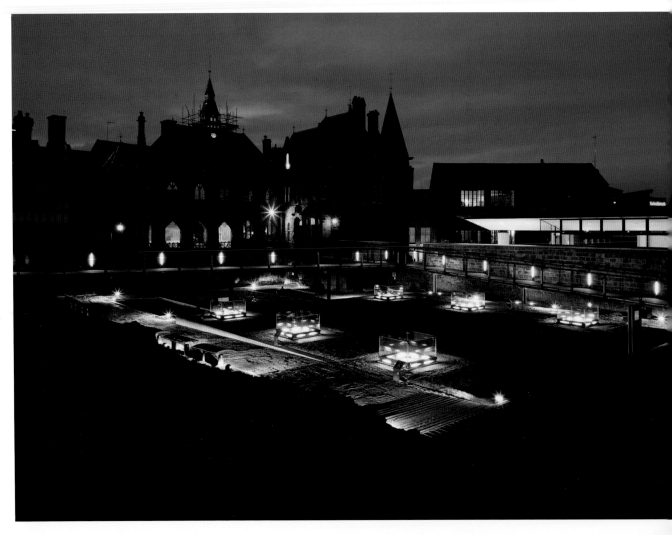

transparent diaphanous sculpture by night. Susanna Heron's poetic water piece sits against a background in which the lighting levels are calculated to be safe but sufficiently low that the light that plays through the water is clearly visible as a backdrop to the space. Alexander Beleschenko's glittering glass bridge is backlit not only to provide sparkle and definition to the glass fins but also a plane of light across which the pedestrian walks, and controlled lighting into the gardens below.

With the completion of the scheme, we believe that the lighting can be seen as a cohesive element of the overall project that helps to define the night-time character and aid the regeneration of the city centre. If light is an essential part of art, so it is to the forms, spaces and surfaces of 'Coventry Phoenix'. With the recent re lighting of Coventry Cathedral and Holy Trinity Church now providing a splendid backdrop to the scheme the Phoenix by night truly rises from the nightscape of the city to provide a beacon – light as a symbol of a new Coventry built out of the shadows of the past.

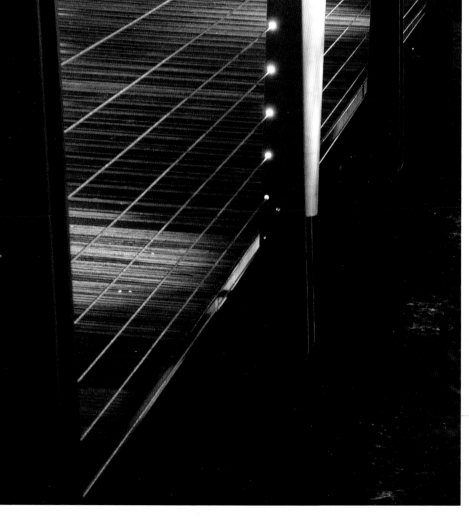

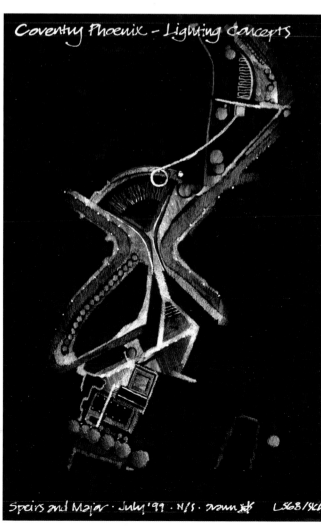

Coventry Phoenix - Lighting Concepts

Speirs and Major · July '99 · N/s · drawn SCd LSG8/SKD

THE MAKING OF THE PHOENIX INITIATIVE
HUGH PEARMAN

PRIORY GARDEN

Walking west across the cathedral close, Priory Row passes between the medieval Holy Trinity Church, one of Coventry's famous three spires, and the new sunken Priory Garden, which is the first of the new Phoenix public spaces. The garden is on the site of the former eleventh century Benedictine Priory church where legend has it the Earl of Leofric and Lady Godiva were buried.

The garden is formed from a three metre deep archaeological excavation of the site down to the level of the floor of the Priory church, which was reconstructed in the fourteenth century. The linear plan of the garden reflects the plan of the Priory church itself with walls, piers, nave all visible elements within the completed design.

The Blue Coat School is constructed off the base of the north-west tower of the original frontage and was built in two phases between 1856-57. During the construction of the second building, the main school room, the west end of the old cathedral was discovered,

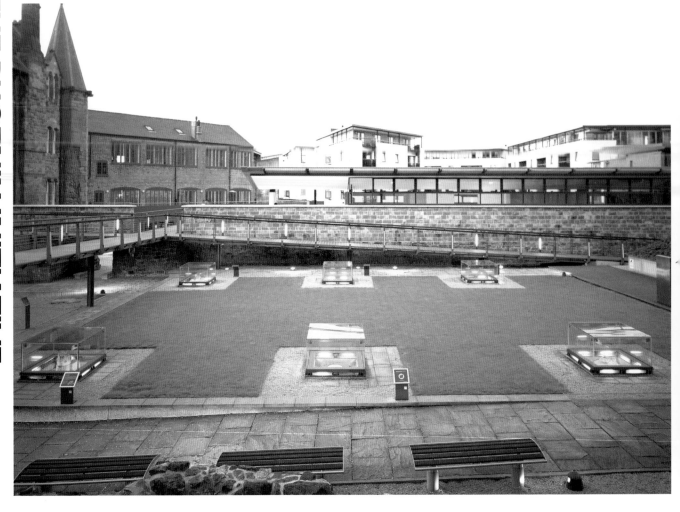

RDA with Chris Browne, Priory Garden, 2001, view looking north with MJP's Priory Visitors' Centre and Priory Place beyond. Photo Marc Goodwin.

A PROCESS OF ENRICHMENT

Coventry is a small city, one where the centre is a short, pleasant walk from its fine understated modernist station. You dodge the ring road with ease, weaving your way through immaculately maintained gardens to the now historic early post war shopping malls and, a little beyond them, the rebuilt cathedral. That is where the trail used to go cold, where the badlands began. But now the journey continues, in a sequence of urban incidents from the twin spired mediaeval centre out towards the edge on the far side, ending for the moment at a city wall-cum-road that is, like so much in Coventry, both old and new. This new route is the Phoenix Initiative, which contains buildings but is not about buildings. It is about public space, about time, history, contemplation and movement.

As a walker, this is how you encounter it. Starting at the great churches in the dense historic core, the route drops down the slope, taking turnings, yielding surprising spaces, gradually opening up along with the grain of the city. Walking at your shoulder are the artists commissioned

to charge up the spaces in a variety of ways. You start at Holy Trinity churchyard and move across Priory Garden, site of a revealed archaeological layer. A bridge takes you across, or you can descend into it. The new visitor centre for the site acts as an inhabited wall between this and Priory Cloister Garden one level down, a quiet retreat as a cloister should be, but filled with the recorded murmuring voices of Coventry residents. From here a window behind a waterfall yields a mediated glimpse of the next level down, Priory Place with its splashing pool. This rhomboidal area, hemmed in by new apartment and retail buildings, debouches into the pinch-point of a relatively narrow alley: the necessary compression before the almost agoraphobic release of the largest space in the scheme, the fan-shaped Millennium Place. It occupies the site of what was previously a busy traffic crossroads dominated by the abandoned bingo hall of the former Coventry Hippodrome theatre.

Above you at this point two imposing metal arches, just touching at their apex to form a single bifurcating structure known as the Whittle

and subsequently left on public display, and can be seen to the left from the bridge, which crosses the site from Priory Row. The school lay empty after it was abandoned during the Second World War. It was the first listed building to be refurbished in the Phoenix Initiative, a job that was undertaken by architects Brownhill Hayward Brown. It now accommodates the Holy Trinity Church Centre.

The remains of the once immense Priory Church continue under the eighteenth century buildings on Priory Row, and sections of the eastern apse can be seen adjacent to the Spence cathedral.

The south nave wall was discovered as part of the excavations on the site and is visible at the bottom of the bank off Priory Row. The north nave wall is reflected in the rough stone wall on the other side of the garden, it was built off the foundations on the original north nave wall (sections of which are visible in the Visitors' Centre) by successive generations using stone robbed from the Priory following its dissolution in the sixteenth century.

This quiet contemplative space contains interpretative interventions ranging from artworks by Chris Browne created from objects discovered as part of an extensive archaeological excavation, to an animated computer reconstruction of the Priory Church on screens located at the centre of the nave. Since its inauguration, the space has been used for dance and drama performances, recalling the tradition of Coventry Mystery Plays, which would have been at their zenith during the era the priory was in existence.

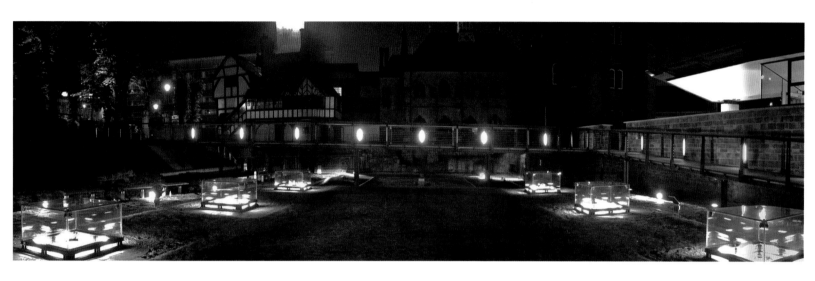

Priory Garden at night looking west towards Blue Coat School. Photo Michael Rummey, RDA.

Arch, form the visual link between what are essentially the two halves of the scheme. From here on, the design gestures are broader. A new façade to the Museum of Transport defines the edge of this new public/events piazza and sweeps round to the cantilevered spiral ramp of a blue glass ribbon pedestrian bridge conceived by MacCormac Jamieson Prichard (MJP) and Rummey Design Associates (RDA) and designed by Whitbybird and artist Alex Beleschenko. This then takes you on an elevated walk over leafy public gardens and the old city wall before depositing you in a new landscaped area just before the elevated ring road, itself acting as a gateway to the city beyond. Here you find the restored Lady Herbert's Garden next to the new Garden of International Friendship with its maze.

The walk back is differently rewarding in that it takes on the character of an ascent on the citadel of the urban centre as marked by the twin spires. The whole distance travelled is not more than around 400 metres but perceptually the distance is much greater: you cannot take in the whole stepped and cranked route from any one vantage point,

while each section has a very different character from any of the others, and these in turn yield subsidiary, threshold, spaces. The contribution of the artists in helping to define and personalise the character of each section – and the transition between sections – is highly significant and is discussed elsewhere in this book.

The project's name is a resonant one, for Coventry, devastated by bombing during the Second World War, has long seen itself as a Phoenix-like city. "Phoenix at Coventry" was the title Sir Basil Spence chose for his 1962 autobiographical account of the building of his new cathedral, which embraces the gutted ruins of the old. Spence quoted the composer Bela Bartok: "Only a fool will build in defiance of the past. What is new and significant always must be grafted to old roots." At the time of the architectural competition for the cathedral in 1950-51, such belief was anathema to the British avant-garde who saw Spence as a throwback architect.

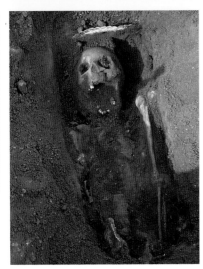
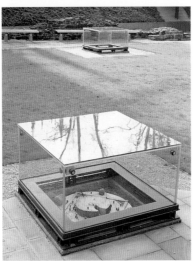

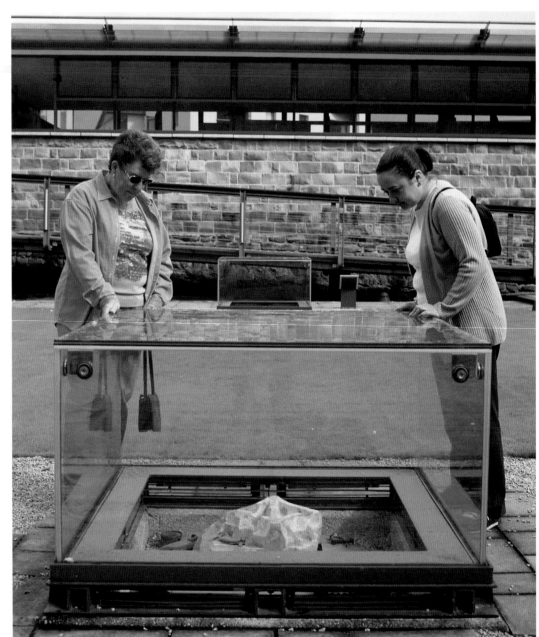

Above left: One of the 1,500 burials that were exhumed and relocated as part of the site excavations. Photo Chris Browne.

Above centre and right: Chris Browne, photographic research/source material for *Cofa's Tree*, 1998-2002, from her residency with the City of Coventry Archaeology Department. Photo Chris Browne.

Right: Chris Browne, one of a series of vitrines in the Priory Garden containing sculptures from her residency with the City of Coventry Archaeology Department. Photo Marc Goodwin.

CHRIS BROWNE

As a local artist, the Phoenix Initiative provided me with a unique opportunity to create a work of public art which expressed my feelings for the city where I was born, and to give something to its inhabitants – past, present and future.

I wanted to create a work of art for Priory Garden based on the idea of "a walk of a thousand years", the starting point being the floor of the medieval priory of St Mary's and the foundations of Coventry's heritage.

Little was known about the history of the priory, although there was much speculation and many legends. Its history had been hidden from view, buried, unknown. I focused on the priory floor and built up information and material, layer upon layer, exposing clues and establishing multiple links from which the artwork would evolve in parallel with the archaeological dig, and the architectural and landscaping process.

By using simple metaphor and multiple imagery I related a story about the roots and development of this interesting city. My aim was to produce a multi-faceted, multi-layered artwork which echoed the site and inspired people to ask questions and to remember...." Was it always there or did you put it there?" I hope to encourage them to excavate their minds through a series of clues and visual poetry and to establish a network of links with other artworks around the city and beyond.

Chris Browne, *Cofa's Tree*, 1998-2001. Photo Peter Durant/ Arcblue.com.

PRIORY CLOISTER AND VISITORS' CENTRE

Wide steps or winding ramps lead from the bridge that crosses Priory Garden down to Priory Cloister. The cloister, enclosed by a new red sandstone wall, with implied ambulatories formed from pleached lime trees, was built on the site of the original priory cloister. The ground plane is disengaged from the enclosing wall by a recess, which glows blue at night. David Ward has created an artwork, *Here*, for the centre of the cloister. Eight outdoor speakers elevated on posts relay individual compositions of recorded voices. The effect is of 'whispering trees' recounting concurrent memories of Coventry's past. At night the blue glow to the internal perimeter of the cloister has the effect of dematerialising the space, suggesting a transitory quality such as that of the original cloister or the memories shared in the space.

To the north of Priory Cloister the Visitors' Centre has the multiple uses of explaining the locality's rich history, exhibiting the impressive archaeological findings discovered while preparing the site for construction, and providing a meeting space for The Multi-Faith Group, an organisation set up to encourage understanding and co-operation between Coventry's diverse religious communities.

MJP, Priory Visitors' Centre, 2000, entrance and stairs leading down from Priory Garden. Photo Peter Durant/Arcblue.com.

Time has softened that view. There is a new and growing respect for Spence, while Bartok's dictum – which Spence no doubt intended as a wry commentary on the way much of the post war reconstruction of British cities was going – could almost be taken as a motto for the Phoenix Initiative. But in one sense the critics of the immediate post war period were correct. In Spence they saw monumentalism – what he, a Scot, described as "the English tradition – the true tradition" – being handed down from the then deeply unfashionable Lutyens. You can find a historic continuity with the new project, too, since one of its designers, Sir Richard MacCormac, as a youth once briefly worked in Spence's office. But the intellectual continuation here is, with the notable exception of the Whittle Arch, anti-monumental. If there is a memory of Lutyens in all this, it is the Lutyens of architectonic landscape design: the Lutyens who planned outdoor spaces as fluently as indoor rooms, who collaborated on equal terms with garden designer and plantswoman Gertrude Jekyll, with whom he often had heated arguments. The design discussions from the mid 1990s – between architects MJP, landscape architects and urban designers Rummey Design Associates, the phalanx of artists marshalled by Vivien Lovell of Modus Operandi, and the clients as represented by the city's project manager, civil engineer Chris Beck – similarly frequently hit the critical temperature necessary for fusion.

Building on the past in Coventry means building on many kinds, many layers, of pasts. One of those pasts happens to be what is now historic modernism, in both architectural and engineering terms.
The city's ring road, for instance, is as much a part of this palimpsest as the fragments of medieval city walls. The Phoenix Initiative is about

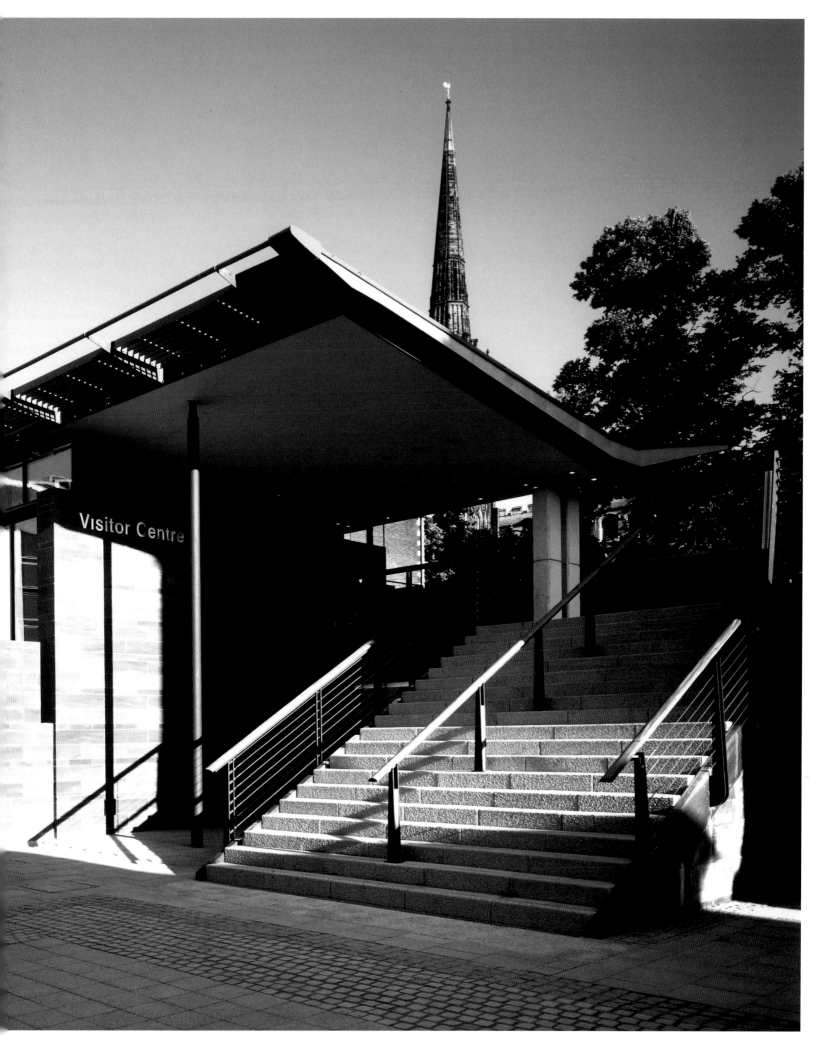

The building has been designed to express the transparency and openness of its use. Although distinctly modern, it adopts the contextual use of red sandstone employed in the original Benedictine priory, and the adjacent Holy Trinity Church. Indeed what remains of the priory's original fourteenth century north nave wall has been preserved, revealed and built upon with a matching red sandstone to create the south wall of the centre. The original fourteenth century wall is revealed through an aperture in the floor, and a section of an eighteenth century wall, built on the fourteenth century foundation using stone robbed from the monastic ruin, has been retained and restored. A slate creasing defines the break between this and a section of matching new coursed rough stone walling. This wall expresses the layering of the site and the nature of the new interventions. A simple canopy roof appears to float over this red wall, raised on a band of clerestory glazing that runs along its length. The north façade is fully glazed in order to create a continuity of space with the cloister.

The sloping site has created an opportunity for two entrances to this two-storey pavilion. The upper entrance is from the new raised walkway passing over Priory Garden, which gives direct access to the upper floor of the building and in particular the Multi-Faith Room. This meeting room sits as a building within the building, disengaged from the exterior walls of the Centre, so creating areas of double height space around the edge of the interior. The asymmetrical roof profile is visible within this space, and a balcony along the northern edge of the meeting room gives views of the north nave exhibition below.

The lower entrance on the ground floor gives direct access to the 250 square metre gallery. This space is punctuated with columns on a five metre grid supporting the meeting room above. A grey marble tile floor creates a visual link with the exterior terrace and the Priory Cloister beyond, through a full-height glazed façade.

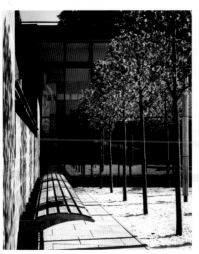

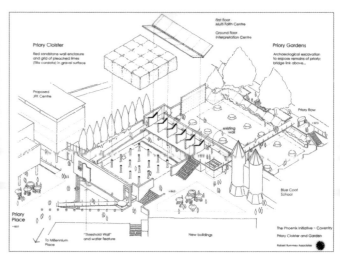

Left: MJP and RDA, Priory Cloister, 2000, view of east wall looking towards the Visitor Centre. Photo Peter Durant/Arcblue.com.

Centre: MJP and RDA, Priory Cloister, 2000, view through gate. Photo Michael Rummey, RDA.

Right: RDA, Concept axonometric of Priory Garden, Cloister with the Visitors' Centre, 1998.

picking a route through all this, revealing a part of the city that had become moribund, allowing people to appreciate the city in a new and different way.

What you see now, and what the original idea of the city was, are two very different things. As Chris Beck recalls, originally the city was planning a 'landmark project' in the specific sense understood by the Millennium Commission. Official landmark projects to mark the Millennium would attract funding of around £50 million towards an overall cost of £100 million or more. To this end, the initial thinking was for something that came close to the older notion of comprehensive redevelopment: a huge axial series of spaces and buildings. Who knows what may have resulted had such funding been obtained – the idea of an all-new transport museum and even a Utopian-sounding "Academy of National Achievement" were mooted – but it was not. The Phoenix initiative became a smaller and, as it turned out, more urbanistically fruitful project. There was to be no shouting and waving, no self-conscious building of icons for the sake of icons. Something different, and still highly ambitious, would be attempted.

Key to this is that the scheme is driven by public space, not conventional architecture. New and refurbished buildings serve to channel the energy of the route with its series of incidents, but the route is the thing, not the buildings. This amounts to a reversal of normal practice: it is rare to find such a very architectural project that eschews object/buildings. It implements an exactly opposite approach to that of normal redevelopment. Conventionally a developer would take an untidy, run-down bit of town, sterilise it and apply an object/buildings formula for rebuilding. The interesting, quirky aspects to old bits of town always disappear as a consequence.

In contrast the Phoenix Initiative, for various reasons, not only discovers and reveals parts of the existing city, but creates some almost medieval, cheek-by-jowl places of its own. It acknowledges and enriches, when a conventional development more usually ignores and impoverishes. MacCormac ascribes much of the logic of this approach to the simple fact that it is a public sector-led scheme, and they were able to select development partners who shared their values and wanted to add to the vision.

MJP, Priory Visitor Centre, 2000: south elevation from Priory Garden. Photo Peter Durant/Arcblue.com.

This process of enrichment is helped by happenstance, the designers being light on their feet, their scheme highly adaptable – as MJP managing director and project architect Toby Johnson points out, at first there were no new buildings to speak of in the scheme at all, which meant no defining edges at key points. At the same time other buildings which needed removing proved obdurate. A development partner was selected in the shape of Complex Development Projects, who wanted to work with Coventry City Council and retained the Phoenix design team to carry out the commercial development around Priory Place. With their support and this continuity, the scheme proved capable of carving out its own course and character around obstacles just as a mountain stream does. The end result is immeasurably better than the axial plan originally in the competition brief.

"It changed into something much more interesting and, to be frank, something rather different to the way I normally think about urban architecture", says MacCormac. "Instead of being a series of formal propositions – a promenade in a rather Parisian way – it turned out to

be a series of landscape and urban and historical episodes, and the episodes were hung on what was there originally."

For Robert Rummey of Rummey Design Associates, the project represents a rare synthesis of skills. As urban designers and landscape architects, the role of RDA was well forward in the mix. RDA worked on the competition scheme with MJP and continued on from there, with RDA's Dominic Scott becoming almost a fixture. "We worked literally in Richard's office for months, years", says Rummey. "We'd discuss it, pull it to pieces, hold review meetings. It was rigorous – no holds barred. There were no professional boundaries, because the external spaces in the scheme are so intimately involved with the buildings."

Rummey is clear what the Phoenix Initiative is all about. "We saw it as a journey through time, and we had many levels of time, from the old priory to the future as represented by the glass bridge. And it's done as a sequence of spaces rather than a sequence of buildings. Quite intense spaces which all have a different character. It was a story that people could understand."

HERE
DAVID WARD

I wanted to include people who talk in images so that as listeners we might, so-to-speak, see their recollections in the mind's eye. These are sample extracts of different voices from the recordings included in the work.

"The first time I saw the sea I was 14.... We used to go off on the back of a coal lorry to Weston-Super-Mare.... But of course we never saw the sea because it was never there."

"When I came it was snowing, and it was a sort of shock, but I was not afraid of snow because in Pakistan – north west frontier – there was snow there. So that was a good experience, to be welcomed by snow."

"We could see the three spires.... On a clear day you could see the wireless masts at Daventry, it seemed like a miracle to see that far."

"I saw it [the cathedral] being built.... On the day it was being topped out the big flying cross was being lowered... there were these three big helicopters. It was amazing, absolutely amazing to see that done."

"Both of us worked on it [a cathedral door] as something very special and we were rewarded, not in money but we were rewarded in a different manner for the work that we were doing there."

"I remember my cousin coming with parachute silk.... Making petticoats out of parachute silk... skirts being made out of blackout material."

"We had our special siren suits to wear... warm little suits with hoods attached... to keep us warm in the shelters because they were damp, corrugated iron, candles – siren suits, yes."

Left: David Ward, Well, One Thousand Lights, 1997, temporary Installation for the Royal Pump Rooms and Baths, Leamington Spa. Commissioned by PACA. Photo Rod Dorling.

Right above: David Ward, Temporary Lighting Installation, 1991, King's College Chapel, Cambridge. Photo David Ward

Right below: RDA, MJP, with David Ward, Priory Cloister, 2000, with lighting by Speirs and Major following Ward's design. Photo Mandy Reynolds.

Opposite: David Ward, MJP and RDA, Priory Cloister, 1998-2000. Photo Marc Goodwin.

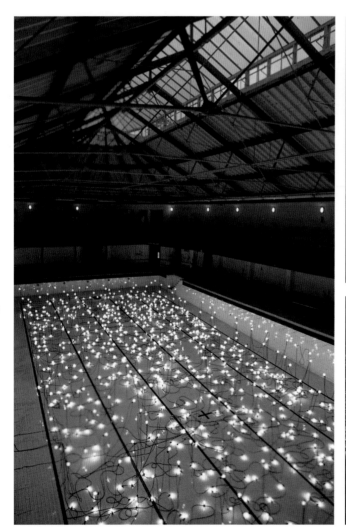

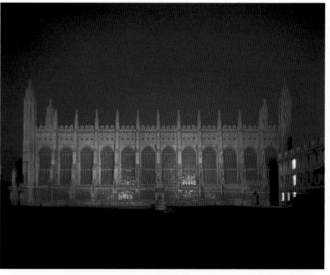

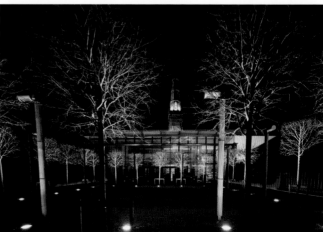

"When I came out of the forces I had an apple green jacket, drape, one button, American style.... I had a turquoise tie with this.... Our Jean sewed my initials on it in sequins so when we went dancing and that spotlight hit it...."

"I was never a girlie-girl... always a tomboy.... I used to go to the Speedway with my dad and carried on ever since.... We sat out on the Coventry Bend with a lot of other people and it was good."

Here was made with the technical assistance of sound consultant Tom Cullen. The content of the work was edited from the sound recordings of the Coventry City Oral History Archive with the special help of Robin Johnson, Senior Life Long Learning Officer and Martin Roberts, Senior Curator, at the Herbert Art Gallery and Museum, Coventry. The design of the speaker columns was realised with the expertise, in particular, of Chris McCarthy at MJP.

RIBBON FACTORY

To the west of the cloister is the old Ribbon Factory. A remnant of Coventry's once vibrant ribbon industry; this has been carefully restored and refurbished by developers Complex Development Projects (CDP) and PCPT Architects.

The 1849 building comprised a factory with adjoining owner's house. With 22 powered looms on the first and second floors, the building was the first, and one of only a few, surviving examples of steam powered ribbon factories in Europe. Soon the industry floundered and within 15 years the Ragged School operated here and subsequently a drill hall, armoury, dance school and latterly a betting shop.

By 2003 the buildings had been neglected for ten years, were pigeon infested and in a severely run-down condition. The factory had been constructed directly off the ruins of the priory; by the time the Phoenix Initiative got under way the buildings were propped by scaffolding buttresses to prevent collapse. CDP purchased the building to secure its use as part of the wider scheme and local architects PCPT were asked to design an extension and refurbishment to provide a ground floor restaurant with apartments above, all within the MJP masterplan framework.

To achieve commercial viability and to introduce vertical circulation to the upper levels, the challenge was to restore, adapt and extend a significant listed building at a critical location in the masterplan. The ground floor was extended with the addition of a glass box and a rendered recreation of the cloister, together with a brickwork and cedar clad stair tower to the north-east gable. The former vaults below the factory provide parking for the apartments and ancillary space for the restaurant. Further important remains of the priory were discovered and preserved within the stair tower extension. Above the ground floor, the six loft-style units and apartments at the upper floors are accessed off a balcony deck built off the ground floor cloister.

A new steel frame was inserted and the existing brick stitched in. The floor to ceiling height at the ground floor was raised, but the original low ceiling level of this floor is represented by the original ten metre timber beams and the cast iron columns, which are retained as features within the space.

It is very Coventry in this. There are clear references both to the medieval city and to the post war reconstructed city in the way the route develops. The starting point of the old/new/old cathedral with its emphasis on art and craft is followed through in exemplary fashion right through to its conclusion, where you are presented with a modern city gateway beneath the choke-collar of the city's ring road. This is important: it is not like anywhere else. It could only be here.

The blend of disciplines – architecture, landscape and art practitioners working together and informing each others' work – is to some extent in the spirit of Spence's cathedral, that earlier Phoenix project. Here, however, it is done with a very modern sensibility, not least in the appreciation of the power of artists as much more than mute servants of the established design.

The artists were not on board at the time of the original competition, though Vivien Lovell of Modus Operandi was on hand to produce an arts strategy. The end result of this was to create another shift in conventional perception of how these things are done. "The sheer scale of the interventions of artists, the capacity of artists like David Ward, Susanna Heron, Jochen Gerz and Françoise Schein to engage with Coventry's history – that's all stuff that we couldn't have expected, and which an architect, in a conventional sense, would not have done", says MacCormac.

Even Lovell, who has steered her ambitious public arts strategy to fruition remarkably intact, was intrigued at the way things turned out. "I'm amazed at how much the original vision has come through to reality", she says. "That says a great deal not only about the artists, but also about the client in accepting it. At the start, some people were still thinking about statues of city worthies on plinths. There was a huge learning curve to establish that public art could *be* public space."

Lovell was able to explore ideas she had long nurtured, and on a grand scale. "What fascinated me from the very beginning was the scope that this offered whereby artists could, with other professionals, design public spaces. The fact that it was a fractured, disparate, site suggested that there could be a whole series of artists who could unfold the site between them."

So it proved, and the worked-up design proposals were communicated with some skill. As Beck says from the client's side: "We built something that looks amazingly like the artist's impression." People bought into the scheme, and this despite some vehement opposition. The memories inherent in the old Hippodrome theatre, for instance, called stronger to some, at least at first, than the process of memory-delineation on its cleared site as outlined by artist Jochen Gerz. But support came too, sometimes from unexpected quarters. Beck remembers going with trepidation to present the scheme – one of such 300 presentations in all – to the local civic society. "They said, Chris – you must do it. History is about the recording of change. And it's true. I believe that every generation has the right to leave its own mark."

As to why this complex design evolved the way it did, that was partly down to pragmatism. Beck recalls sitting in a fraught design meeting

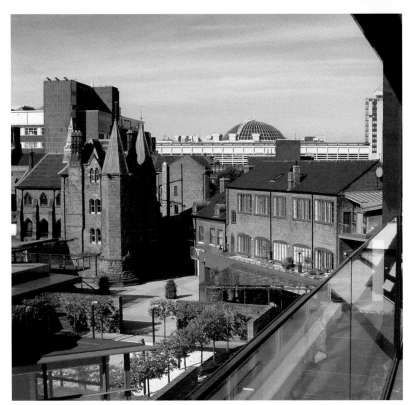

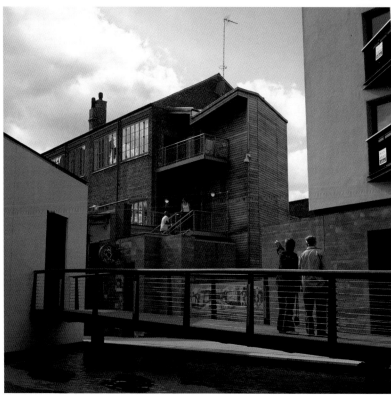

Left: PCPT Architects, Refurbished Ribbon Factory, 2002, with Blue Coat School to the left. Photo PCPT Architects.

Right: PCPT Architects, Refurbished Ribbon Factory 2002, view of new staircase from Priory Place. Photo Marc Goodwin.

Following pages: MJP, Priory Visitors' Centre, 2000, north elevation from Priory Cloister. Photo Peter Durant/Arcblue.com.

when the scheme somehow had to come to terms with the fact that the supermarket chain Sainsbury's refused to consider the rebuilding or modification of its pig-ugly store that stood in the way. During a pause, Beck noticed MacCormac making a rough sketch. This turned out to be the first idea for what became the Whittle Arch – a visual device to lead the eye through the scheme and distract attention from the regrettable lump of the store, shouldering its way in at one side. But such problems can lead to inspired solutions. The squeeze-point that the route is obliged to adopt just before breaking out through the arch into Millennium Place is a textbook deployment of the architectural trick of compression and release.

MacCormac, Rummey, Lovell and Beck all see the completed project as the start of a larger regeneration of the area. Land values have shot up. Because of the 85 apartments in the project, people are now once again living in the city centre. There are linkages to be made: for instance Coventry's canal basin, connecting to the entire English waterways network, is very close to the present terminus of the Phoenix Initiative, but separated from it by the ever present ring road. The city's main bus station, architecturally woeful, presses hard up against Millennium Place and – like the obdurate Sainsbury's – will clearly yield sooner or later to the regeneration force unleashed by Phoenix. Other buildings now in hand will give Millennium Place more of an urban edge, as planned. As Rummey puts it: "We want the ripples to spread."

The Phoenix Initiative has prised open a previously intractable part of the city, establishing a fissure of possibility. As MacCormac reflects: "Space as an embodiment of civic virtue had become something it was not easy for many people to believe in." They are free to believe now.

A REDEMPTIVE ALLIANCE: ART, ARCHITECTURE AND LANDSCAPE IN THE RENEWAL OF COVENTRY

RICHARD CORK

The savage and relentless damage inflicted on Coventry over the last few centuries can be felt wherever we walk. At the end of Cuckoo Lane, where the last public execution in the city was staged in 1849, a row of impressive Georgian houses still survives in Priory Row. They demonstrate the eighteenth century's outstanding architectural prowess. But a glance down Hill Top Lane discloses the alarming proximity of some banal post-1945 rebuilding and, in the distance, a concrete inner ring road ensnaring the city's heart.

Further down Priory Row, we encounter the melancholy remains of the once-resplendent Cathedral of St Mary, completed by the Benedictines around 1220. It was, by all accounts, among the most ambitious Romanesque buildings of the period, and yet the entire edifice was destroyed by Henry VIII at the height of his nationwide barbarism. In the medieval period, St Mary's stretched a prodigious 425 feet along this commanding site, twice the length of the substantial Holy Trinity Church still intact nearby. Now, by contrast, St Mary's is far less visible than Coventry's next major victim: the

Gothic *tour de force* of St Michael, battered and burned out by Nazi bombers in a cruelly accurate nine hour Blitz attack on the night of 14 November 1940. The much-restored tower of St Michael's remains standing, along with the scarred hulk of its once-graceful nave. But the loss remains incalculable, and elsewhere in Coventry the wholesale effacement of history was grievous indeed.

True, Basil Spence succeeded in healing some of the city's multiple wounds when he designed a new cathedral, sensitively preserving St Michael's and treating it as the aesthetic springboard for a building where contemporary painters and sculptors were given surprisingly prominent roles to play, both within the structure and outside. Spence's interior is unimaginable without the images produced by John Piper and Graham Sutherland. Few modern architects would have been prepared to give artists' work such dominant positions within a building, but Coventry's post war cathedral is memorable, above all, for the monumental contributions made by Piper's effortlessly luminous stained-glass window and Sutherland's looming,

PRIORY PLACE

Further wide steps or a continuation of the ramp that runs around two sides of Priory Cloister lead into Priory Place. Devised as a convivial meeting place surrounded by bars, cafés and shops, this new space was created in partnership with developers CDP and architects MJP and PCPT.

The three blocks that define Priory Place are planned to articulate possible routes through the space. The hard landscaping and dramatic water feature, *Waterwindow*. by artist Susanna Heron, reinforce these patterns, which are an expression of the anticipated life and activity of the space.

The architecture of the buildings is layered horizontally to reflect the topographical strata of the site, but also to create an appropriate urban hierarchy to reflect the mix of uses contained. The ground level in Priory Place drops away to the north and east to reveal a battered stone wall forming a sturdy and grounded base to the building. At the level of the plaza, white concrete columns define the public zone,

providing a permanent architecture for the shop fronts. Three levels of flats above are defined by a white render plane cut away to accommodate recessed and projecting bay windows each designed to capture views or sun. An attic storey of penthouse flats is expressed by a continuous perimeter loggia constructed in lightweight steel and timber that picks up the detailing and secondary rhythm of the balconies below.

Opposite: Looking through the threshold wall from Priory Cloister to Priory Place as part of Susanna Heron's, *Waterwindow*, 1998-2003. Photo Marc Goodwin.

Right: MJP and RDA, Priory Place from the north with Susanna Heron's *Waterwindow*. Photo Susanna Heron.

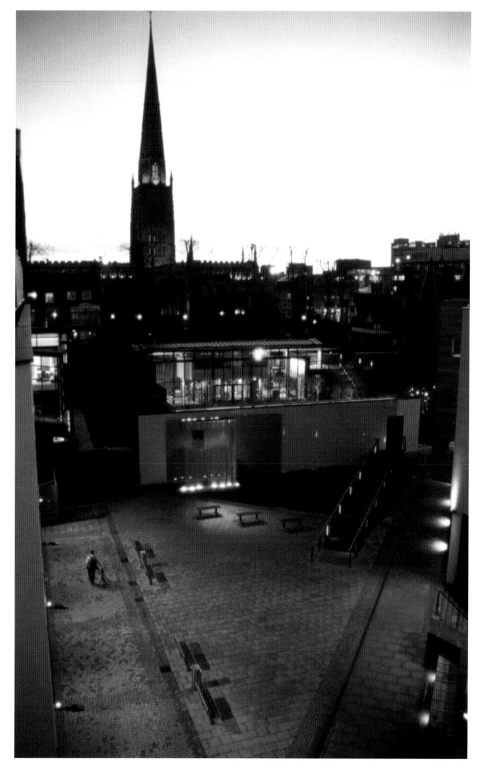

WATERWINDOW
SUSANNA HERON

Waterwindow is a spatial work of sound and light responding to the dividing wall between Priory Garden and Priory Place. At the corner of Priory Garden you first hear the sound of rushing water through the deep copper-lined window opening ahead of you and see a curtain of water falling behind it. Looking through the window you find that the aperture magnifies the sound and acts as an 'ear' to the waterfall in Priory Place. The interior of the window is obliquely angled to channel your view and begin to draw you down the path along the wall and down the walkway into Priory Place.
At certain times a patch of sunlight falls through the window and floats on the waterfall reflecting my preoccupation with the day and the passing of time. At dusk the work is illuminated to create reflected light and luminous water for the busy square. The copper will develop over the years in response to the waterfall recording the subtle tracery of falling water.

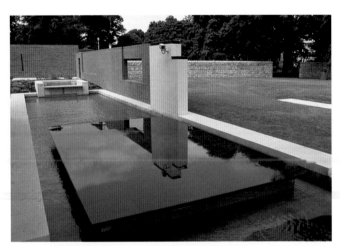

Above left: Susanna Heron, *Island*, 1994-1995, British Embassy, Dublin, commissioned by PACA for the Overseas Estate Department. Photo Susanna Heron.

Above right: Susanna Heron, Proposal for *Waterwindow*, 1998. Photo Susanna Heron.

Right: Susanna Heron, *Waterwindow*, detail, 1998-2003. Photo Susanna Heron.

Opposite: Susanna Heron, *Waterwindow*. Photo Susanna Heron.

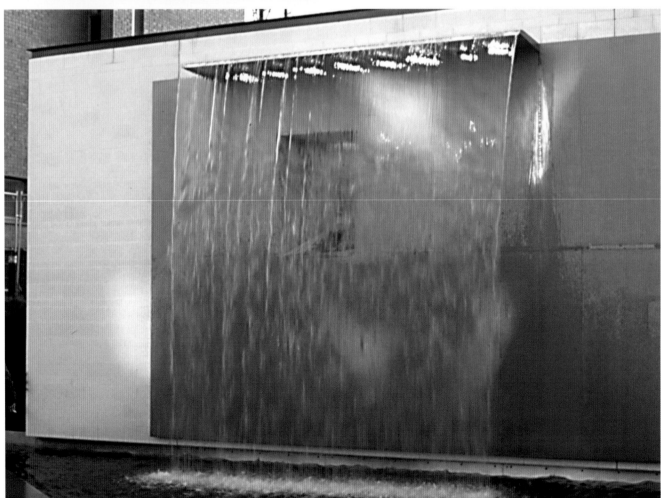

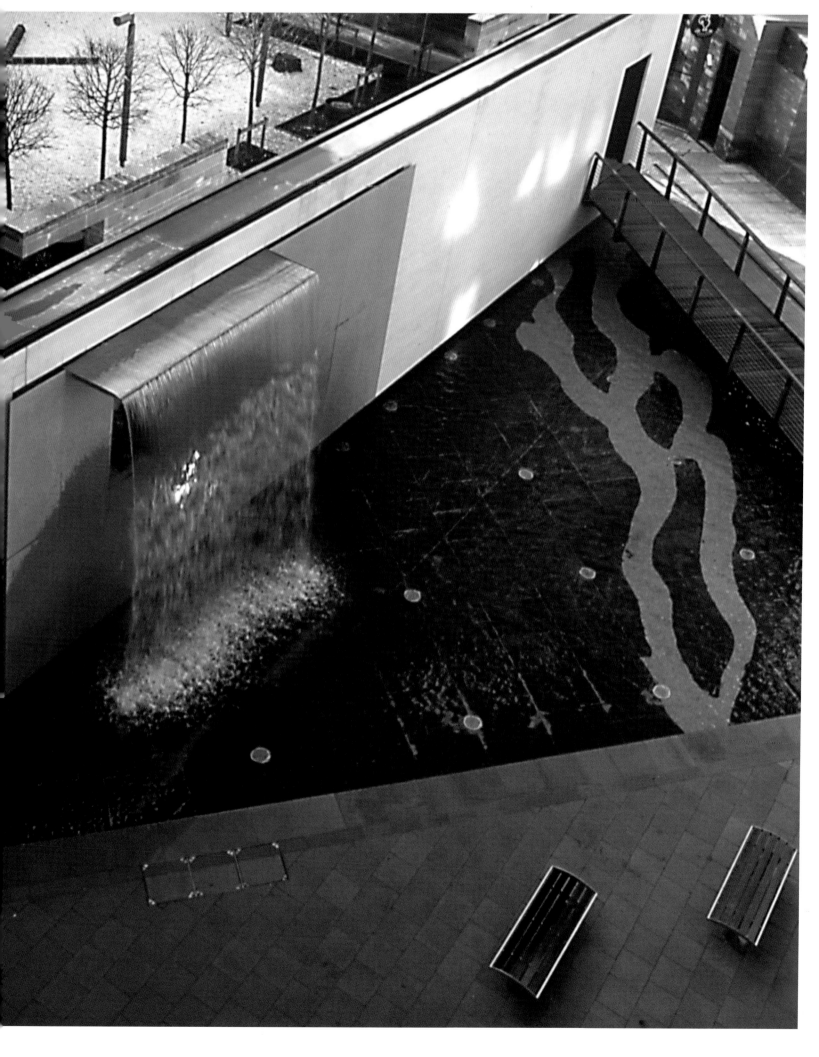

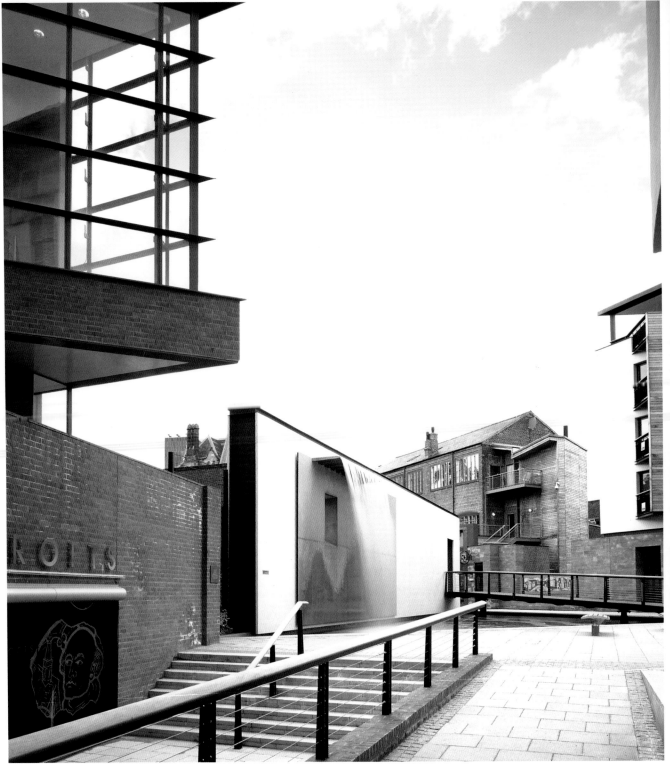

Youell House and the Priory Undercrofts in the foreground with *Waterwindow*, by Susanna Heron, and the Ribbon Factory beyond. Photo Marc Goodwin.

stubbornly insistent tapestry. Spence's willingness to give Jacob Epstein and Geoffrey Clarke important exterior locations for sculpture turned his cathedral into a manifesto for the alliance between art and architecture announced at the Festival of Britain a decade before. When the building was consecrated in 1962, with a potent world premiere of Britten's elegiac *War Requiem*, it was widely regarded as a landmark in the protracted attempt to achieve a sense of reconciliation.

Even so, it would be a mistake to assume that the traumatic devastation in Coventry was wholly redeemed by the advent of Spence's enlightened efforts. They may have offered welcome consolation at the time, but the new cathedral was not accompanied by any other discernible attempts to help the city achieve a full recovery. Like so many other English urban centres pummelled by the Luftwaffe, Coventry suffered from a disastrous amount of anonymous, cut-price and drearily insensitive redevelopment during the post war period. Far from compensating for the destruction

unleashed by fascist bombs, these dismal new streets and pedestrian precincts served only to underline and exacerbate the losses incurred throughout the city's heartland.

That is why the £50 million Phoenix Initiative, commissioned seven years ago by Coventry City Council, has been so timely. Blighted by neglect and disfigured by mediocre structures erected during the most dismal period of twentieth century architecture, the centre urgently needed a transformation. Once counted among the most important cities in England, Coventry had deteriorated into a no-man's-land where incessant traffic and fast-decaying, low-budget buildings alienated the local population. No one wanted to linger in the city, let alone savour the surviving remains of 1,000 years of history waiting to be discovered there.

Now, at the end of an ambitious and sustained regeneration, the change is palpable. People now realise, with a growing sense of wonder and relief, that Coventry has once again become a centre

YOUELL HOUSE

Youell House located to the north of the site and built by Coventry City Council Architects to the designs of MJP, provides new administrative accommodation for the cathedral. The design seeks to mediate between the scale of the eighteenth century houses on Priory Row whose back elevations it faces over a shared garden to the south, and Priory Place, which it overlooks to the north. Conceived as a simple box under a floating roof, the north elevation is distorted to form features such as the stair tower and a prominent pointed bay window which projects out over Priory Place.

The Conservation and Archaeology team of Coventry City Council checked the archaeology of the site of every new building in the masterplan, in order to protect whatever was found from the new foundations.

On the site of Youell House, ruins were uncovered standing five metres high in some places, leading to a full excavation of the whole footprint of the building, which was constructed over the most significant archaeological finds.

The most important treasures from the dig are now on permanent public display, thanks to a grant from the Heritage Lottery Fund. They can be viewed from Priory Place through a glass window across the full width of the priory undercroft. Guided tours are also conducted.

Digs supervised by the city's retiring archaeologist Margaret Rylatt, under the team leadership of George Demidowicz, began in 1999, but the contract was too extensive to carry out in-house and so the work was done by Northamptonshire Archaeology Unit.

Almost half of the 1,500 stones unearthed – including carved heads now displayed in the Visitors' Centre – have been categorised as being of outstanding quality and significance internationally. Finds include painted stonework, mosaics and much of the fourteenth century monks' undercroft. All the carved stone found on the site has been retained on the site in stone stores created from voids under Priory Place.

"Many of the monks would have suffered from arthritis and gone down into the undercroft below their dormitory to warm themselves by the fire. This area has been preserved and can be viewed through the glass frontage in the basement of Youell House." Margaret Rylatt

MJP, Youell House, 2003, within the context of Priory Place. Photo Marc Goodwin.

worth exploring. Some of the most nightmarish excrescences perpetrated by post war redevelopment, a pre war bingo hall and the inevitable multi-storey car park, have been swept aside. In their place, a pedestrian route punctuated by carefully judged surprises enables visitors to rediscover the full, multi-layered richness of this much-abused city. And Basil Spence would be delighted to realise that the project's architects and masterplanners, MacCormac Jamieson Prichard (MJP), worked with urban designers and landscape architects Rummey Design Associates (RDA) on incorporating specially commissioned artworks along the route. Collaborating with art consultants Modus Operandi, they have managed to articulate the full meaning of the renewed urban centre with a succession of well-judged, diverse and unpredictable interventions by artists who employ a supple range of media and working methods.

Rather than imposing arbitrary images on the sites at their disposal, they have ensured that everything is alive to the larger contexts of

Coventry's history. Take Priory Garden, where the ruined west end of the city's first cathedral lie exposed next to the timber-framed Lychgate Cottages, which stood within the forecourt of St Mary's facing an entrance used for funeral processions. Here, in this sunken arena, sensitive attempts have been made to hint at the form of the medieval nave. Without resorting to pastiche reconstruction, the team evokes the magisterial grand plan of the cathedral interior. In one glass case, illuminated at night with a suitably mournful blue light, the artist Chris Browne has placed the poignant stump of Pier 3 South, a half-round shaft once attached to the walls and piers supporting the round arches. But since so little of St Mary's architecture now remains, Browne resorts in the other glass cases to her own sculptural variations on the medieval theme. The most haunting juxtaposes a fragment of Romanesque stonework with the brutal forms of a rusty spanner, cogs and screws. Redolent of the wholesale demolition suffered by the Cathedral, they are accompanied by a verse that includes a chilling command "to pull down to the ground all the walls of the churches".

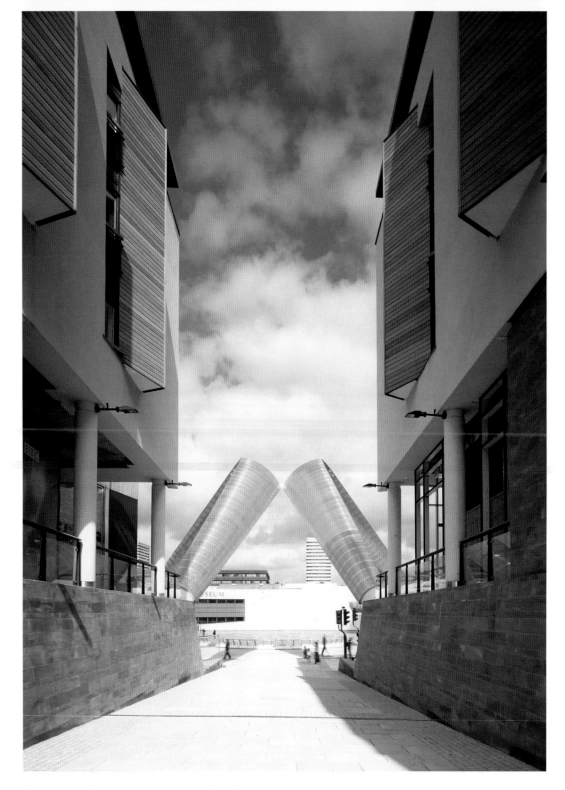

MJP and RDA, Millennium Causeway, 2003. Photo Marc Goodwin.

To her credit, Browne has no intention of sanitising the violence meted out to St Mary's by Henry VIII and his ruthless, thorough-going vandals. Even in the sculpture laid out like an improvised mosaic on ground near the west end, the extent of the damage wrought by the king's henchmen can still be felt. Ostensibly, Browne is optimistic here, taking as her source the ancient legend of Cofa's Tree that gave Coventry its name. Probably an Anglo-Saxon landowner in this district, Cofa may have planted a tree that grew to acquire profound symbolic or religious significance. At any rate, Browne uses a variety of materials to make a freely worked tree of her own, suggesting the city's growth from Cofa's era to the present. Although organic enough, the trunk resembles a splintered column as well. The entire sculpture is filled with references to the vanished cathedral, and the fragmentation of its scattered particles suggests that Browne also aimed at conveying the terrible devastation visited on this site.

The entire sculpture is best viewed from the timber walkway above, leading across the ruins to the Visitors' Centre beyond. Just as the

sunken garden was inspired by the ecclesiastical setting, so care was taken to incorporate the remains of the cathedral's original north nave wall in the Centre's frontage. Red sandstone has been deployed to chime with the medieval material, but the rest of the building does not play around with any faux Romanesque revivalism. Unashamedly contemporary in its minimal transparency and free-flowing openness, it provides an eminently flexible showcase for the carved stone heads, salvaged from the remains of vaulted roofs and ceilings as well as springing-points for arches. These corbel carvings, executed with a freshness and immediacy that suggests they were portraits of the sculptors' friends or workmates, remind us that the cathedral would originally have been embellished with a profusion of images, all fully integrated with the architecture.

In this respect, Basil Spence's enthusiasm for incorporating artists' work in his building revived a distinguished tradition inherited from the Middle Ages. Although most of the medieval art has been irredeemably lost, astonishing discoveries were recently made by

MILLENNIUM CAUSEWAY

Looking down the slope towards Millennium Place the space is channelled into a narrow causeway, restricting and framing views of Millennium Place and the Whittle Arch beyond. The ground plane is sculpted into wide stairs criss-crossed by a winding ramp. The causeway becomes a simple shallow ramp passing between battered red sandstone walls, with giant three-storey bay windows, which fold out of the white rendered walls above like giant shutters, mediating between the scale of Priory Place and that of Millennium Place.

Halfway down the causeway, a cut-out in the stone wall reveals running water. A rough slate surface, against which the water is falling, is set within this cut-out, and is reflected by matching slate slabs on the ground plane. Designed by Rummey Design Associates in association with the archaeologists, this piece marks the location of the Priory Mill Race which would have been the northern edge of the priory enclosure. The Mill Race would have run into the River Sherbourne which remains culverted at the end of the causeway and is marked by an area of blue paving.

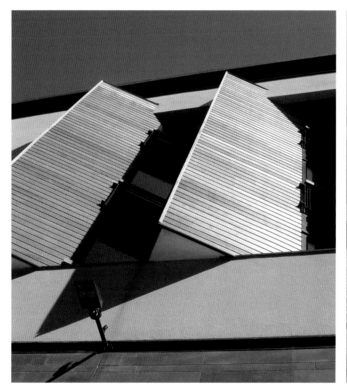

Left: MJP and PCPT, view of projecting bay windows over Millennium Causeway. Photo PCPT Architects.

Right: View of Priory Place at night showing the sculptural treatment of the change in level to Millennium Causeway. Photo Marc Goodwin.

archaeologists working on the site. Two scenes from the Apocalypse, painted on stone around the mid-fourteenth century, offer tantalising hints of the extensive role played by murals in the original cathedral. But the most expressive survivor is a raised boss, placed at the intersecting point of eight ribs in the undercroft and carved with a four-legged running man. Over 750 years have elapsed since this strange, dream-like image was defined with such vitality, openly exposing the figure's genitals as well as his two heads. Even so, it remains charged with the directness and eloquence likewise possessed by David Ward's contemporary work in the neighbouring Priory Cloister Garden.

Although nothing survives of St Mary's original cloister on the same site, RDA and Ward have succeeded in evoking its presence in a spare and subtle manner. Two stumps of medieval columns still protrude from the ground, and the heart of the garden laid out in pale, crushed quartz is marked by intersecting stone ribs salvaged from the cellar beneath the monks' dining room. But everything else

is new, reinterpreting the contemplative mood of a monastic cloister in today's terms. A quadrant of pleached lime trees runs round the garden, accompanied at intervals by simple wooden benches where visitors can meditate, not only on the Benedictine past, but on the vicissitudes undergone by the city in more recent times. To that end, Ward has installed eight wooden speaker columns relaying the voices of Coventry people who share their memories of wartime and its aftermath. From the benches, these men and women sound as if they are murmuring in the foliage of the lime trees.

If we stand underneath the columns, however, their voices suddenly become clear and singular. Most of them have positive stories to recount, often focusing on moments when their city's reawakening from the years of destruction became movingly apparent. One woman vividly recalls her excitement at witnessing the topping-out ceremony of Spence's cathedral: "it was amazing", she says, her voice still filled with wonder. The same sense of awe informs the voice of the man who helped to build the circular chapel. "It was

MILLENNIUM PLACE

Formed from the site of a major traffic interchange and a redundant theatre Millennium Place is a major new civic space for Coventry. Bordered on two sides by roads, it is prominent to all who pass through during the day and at night. It is contained to the north by a cycloramic wall of polished white concrete blocks within which is formed the new entrance to the Coventry Transport Museum. Sitting in front of this cyclorama is a lower racking wall, which follows the line of the ramp that rise gently out of the space before launching into the dramatic cantilevered spiral ramp which dominates the north east corner of the space. Attached to this wall is *Public Bench* by Jochen Gerz a 45 metre long south facing bench that acts as a popular place to stop and watch the world go by.

Millennium View, a mixed-use development by developers CDP and architects Brimelow McSweeney will provide a lively westerly edge to the space once completed in 2005, and it is anticipated that the rag bag of existing buildings that have frontages onto the space will be redeveloped in a way that will offer more interaction and life to

the space. The regional BBC Radio and TV have taken space overlooking it, which will, in time, give Millennium Place a prominence and significance both locally and regionally as a recognisable symbol for Coventry. Already it has been the venue for the major civic and cultural events which will help people identify with it and put Phoenix in their mental map of the city.

Millennium Place itself is a shallow fan shaped amphitheatre formed in black granite falling away towards its apex facing Millennium Causeway. A low wall and balustrade define the southerly edges of the space separating it from the surrounding pavements, with discreet gaps providing access to generous steps that drop down into the space. The surface is dominated by the *Time Zone Clock*, a major artwork by artist Françoise Schein. The work depicts a time zone clock of the world in aluminium castings with inlaid LED strips. Stainless steel discs set within the map locate the capital cities of the world and Coventry's 26 twin cities. At the end of each line the indicators show the hour in that time zone. At the end of the meridian lines (located on the left, viewed from Priory Place)

special", he remembers softly, "and we felt rewarded by the work we were doing there." Ward's marshalling of the contributions is informed by a poetic grasp of interval. We never feel bombarded by these voices. Pauses become as potent, here, as sound. Some of the stories ambush us with their surreal unpredictability. "I can remember skirts being made from black-out material", says one woman, "and they were really quite colourful when finished." Another woman recalls the intense excitement triggered by the advent of bananas after wartime restrictions were lifted at last. "We didn't know what to do with them", another woman confesses, "because we didn't know what a banana was." Ward calls his sound-piece *Here*, and he undoubtedly creates, along with the garden design, a vivid awareness of place. We can share the speakers' lives in this sheltered, meditative setting. As well as listening to a single voice, we become so conscious of the others quietly talking nearby that a strong feeling of community is generated.

We can also hear, just beyond the boundaries of Priory Cloister, the sound of Susanna Heron's waterscape. Initially, it is glimpsed through a deep, slanting window leading to Priory Place. But the wall of water prevents us from seeing this urban space clearly, and only by walking down the bridge can we gauge the drama created on this tight, triangular site. Making a virtue out of the appalling lack of co-operation shown by store owners like Sainsbury's, who refused to demolish their lamentable building, Priory Place narrows as it approaches the immense public space beyond. But no feeling of constriction affects Heron's *Waterwindow* on the opposite side. Falling like a curtain over a wide, equally minimal expanse of copper

sheets, it is at once austere and restful. The sound is powerful, and surely plays a part in enticing viewers to sit on the bench in front. From there, they can see a pale rivulet form meandering through the pool's lining of dark granite. It evokes the medieval mill race flowing under Priory Place from the River Sherbourne, and in that respect Heron invites us to meditate on the invisible forces running through the landscape.

But the speed of the water tumbling down from the projecting canopy also responds to the manifold layers of this complex locale. As our eyes follow the water's four-metre descent, they move from the Gothic spire of Holy Trinity above to the Priory Undercrofts below, discovered in 2000-02 and now exposed to view through a panoramic window underneath Youell House. So Heron's work, for all its conciseness, acts as a unifying link between wholly disparate eras and buildings. It engages, very satisfyingly, with what Richard MacCormac has called the "psychic archaeology" of the site. Moreover, when the flow of water is partially disrupted and scattered by a sudden wind, it suggests the destructive forces unleashed on Coventry at various stages in its history. But the underlying resilience of Heron's waterfall also says something about the city's determination to survive and, in time, reinvigorate itself.

A more spectacular spirit of defiance is conveyed by the colossal steel arches leaping out from the other end of Priory Place. Designed by MJP and engineers Whitbybird with sculptural elan, they soar up and meet in the sky above fan-shaped Millennium Place and then part again, descending to a pair of plinths outside the Coventry Transport

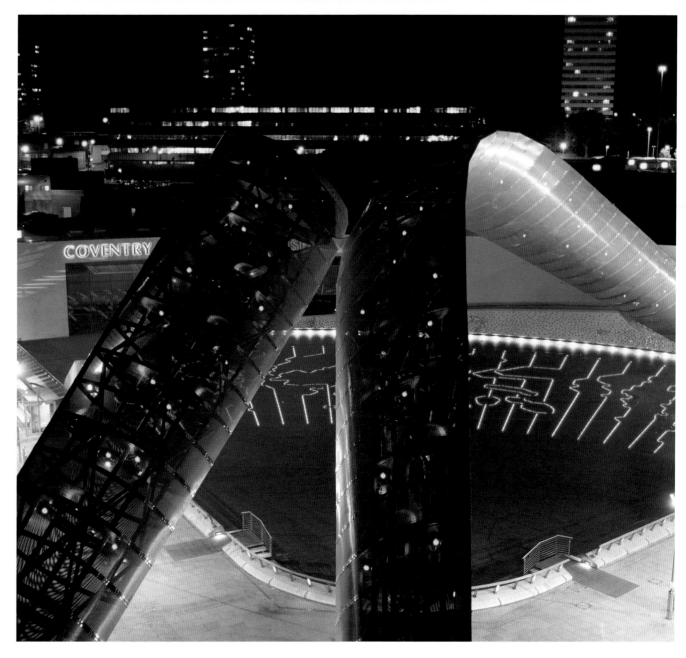

MJP and RDA with Françoise Schein, Millennium Place, 2003, view at night. *Time Zone Clock* was realised with the assistance of Michael Popper Associates. Photo Marc Goodwin.

Museum. It is as if the architects are implying a refusal, on their part, to be defeated by the deplorable proximity of Sainsbury's on one side and, on the other, the bus station with its twee, pseudo-classical temple frontage. Mercifully, the surging arches manage to pull our vision away from these distracting reminders of Coventry's architecture at its most debased. And on ground level, Françoise Schein continues the process by arousing our curiosity with her elaborate *Time Zone Clock*.

Walking across Millennium Place, we realise that the raised forms of the twenty-four zones resemble rivers meandering across an immense, richly irrigated plain. Apart from celebrating Coventry's history as a centre for clock-making, the time zone lines are lit from below with minutes and seconds glowing in dials at the end. After dark, the LED displays illuminate the entire space, and their internationalism is reinforced by the geographical names of Coventry's twin cities contained within circles studding the entire site. They range, dizzyingly, from Accra, Freetown, Monrovia and Bamako to Rabat, Lisbon, Reykjavik and Pyongyang.

The emphasis on names ensures that Schein's *Time Zone Clock* has a felicitous connection with Jochen Gerz's *Public Bench*, an immensely wide curving seat below a wall where hundreds of small, dark red pvc panels proclaim the importance of friendship. Gerz, whose early childhood was spent in wartime Berlin, has long been driven by a fundamentally redemptive urge. He asked the people of Coventry and its visitors to commemorate "a friendship, a secret relationship or a memorable encounter" by proposing two names.

Walking past the proliferation of panels already filling much of the available wall space, we find ourselves delighting in the sheer diversity of the surnames cited here: Coils, Headland, Super, Honey, Hedges, Clover, Elms and (believe it or not) Bayliss-Stranks. After a while the prevalence of bird references becomes beguiling, with Terry and Gloria Nightingale, Olive and Le-Anne Bird and even Eileen and Paul Butterfly. But the multi-nationalism is even more arresting: Coriena Brierley nominated Slavica Stojsavljevic, while Joaquin Arges-Nieto named Luis Ferdinand De Vera. So many people are lauded here, and the fact that the nature of their relationships is left mysterious, on this supremely public site, only adds to the fascination of the venture as a whole.

Taking a rest at the end of Gerz's bench, where the wall of names reaches its highest point, we encounter the spiralling energy of a street bridge conceived by MJP and Rummey Design Associates, and designed by Whitbybird. Enlivened with Alexander Beleschenko's blue screen-printed panels, this lean and unsupported structure rises from Millennium Place and, after spanning the remains of the medieval city wall, eventually descends into the Garden of International Friendship. A walk along the bridge is an exhilarating experience, taking us through and above the branches of mighty cedar trees springing up from the newly restored Lady Herbert's Garden below. Their foliage brushes us when we pass, and the bridge's irrepressible curves are echoed at the far end by Kate Whiteford's planted maze of box hedging and white marble chippings. Best seen from the raised platform abutting the bridge, Whiteford's work ripples its way through the Garden of International

Greenwich meantime in hours minutes and seconds is shown on three indicators. The LED lines light up from left to right from midnight, and at every quarter of any hour (to synchronise with the cathedral bells) the whole clock is illuminated.

Lining the north of Millennium Place is an artwork by Jochen Gerz entitled *Public Bench*. Engaging with local people, the work commemorates a friendship, meeting or special relationship between two people. These are recorded on red plaques fixed to the wall behind the bench. Over 6,000 names are recorded on the wall to date, and it is intended that the work continues until the wall is full.

Another work by Jochen Gerz to the east of the space, entitled *Future Monument,* reconciles Coventry's former enemies, naming them as friends, with illuminated glass plaques ranged around a shattered glass obelisk. Smaller plaques on the opposite side represent community organisations in Coventry who were involved in the artwork.

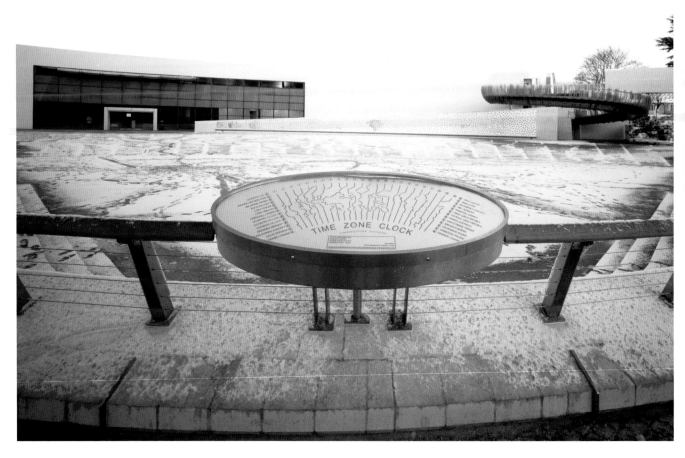

MJP and RDA with Françoise Schein, Millennium Place, 2003, view looking north with Françoise Schein's *Time Zone Clock* control panel in the foreground. Photo Marc Goodwin.

Opposite: MJP and RDA with Françoise Schein, Millennium Place, 2003, view at night looking south. Photo Marc Goodwin.

Following pages: Millennium Place from the spiral ramp. Photo Marc Goodwin.

Friendship. She took as her springboard designs found in Chartres Cathedral, but the pared-down clarity of her maze firmly allies it with contemporary art concerns as well. Nobody looking at Whiteford's contribution to RDA's Dominic Scott's garden can remain unaffected by the inner ring road passing so close by, its dual carriageway cutting the centre off so brutally from the rest of the city beyond. But the compelling rhythms of the maze convey a desire to spread outwards, working towards a new Coventry no longer severed by this traffic-ridden intrusion.

Making our way back from the Garden towards Millennium Place, we find that the need for unifying imperatives is also reflected in *Future Monument*, the second of Jochen Gerz's commissions. Positioned alarmingly near a busy road, it nevertheless affirms a stubborn urge to overcome the catastrophes of Coventry's past. Inspired by the hope that former enemies might become friends, Gerz involved over 5,000 citizens in the artwork. A host of local groups and minorities were offered plaques set in the Monument's radiating pavement.

Their names testify to the intoxicating pluralism that flourishes in the city today. Embracing the Barbadian Choir, the Octavian Droopers, the Shysters, the Shree Krishna Temple, the Badderistas, the Coventry Ukrainian Community and much else besides, they add up to an intensely heartening proclamation of multi-racial vivacity.

Rearing from the centre of all this present-day diversity is Gerz's modest yet sturdily constructed obelisk, its pale green panels of shattered glass sparkling in the light. The restless rhythm of water is evoked within the obelisk, linking it up with Susanna Heron's work cascading down the hill where the Benedictine cathedral once stood. And behind the obelisk stands Swanswell Gate, built around 1440 as part of the fortified town wall. Its survival is something of a miracle, but so is Coventry's determination to revive this pummelled centre with art, architecture and landscape design arising from a unified response to the city's need for renewal. The work produced here seems all of a piece, the result of a coherent attempt to replace centuries of obliteration with understanding, imagination and hope.

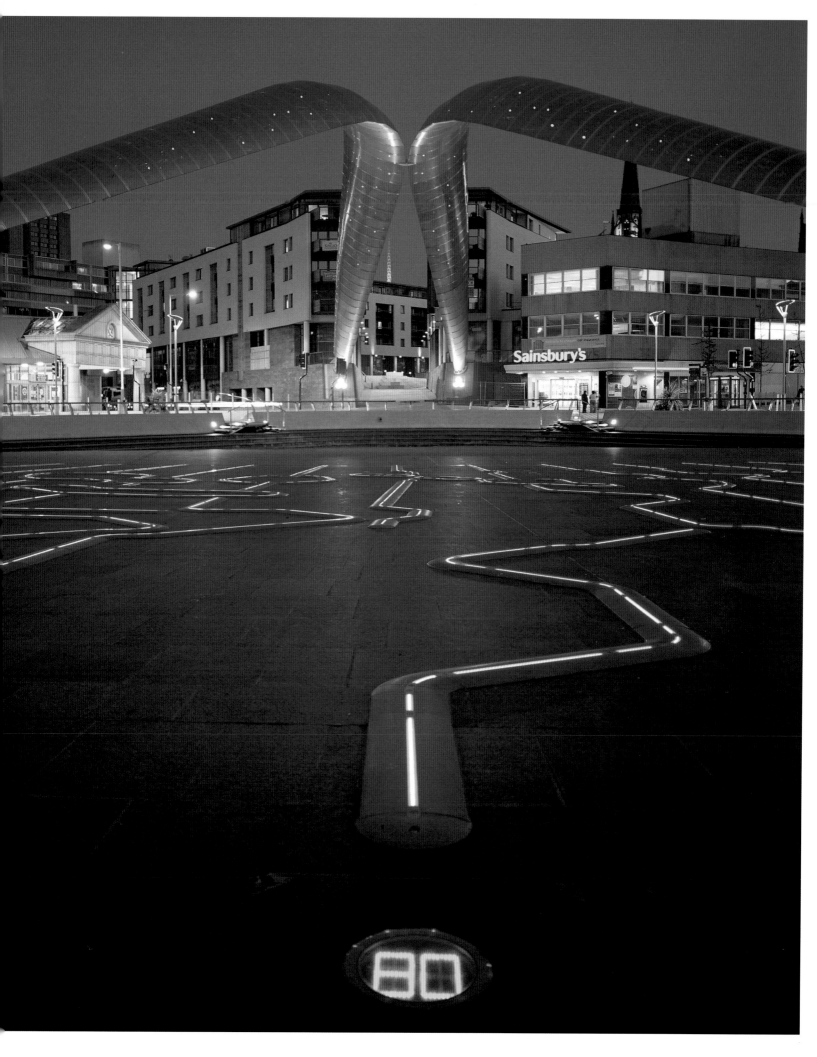

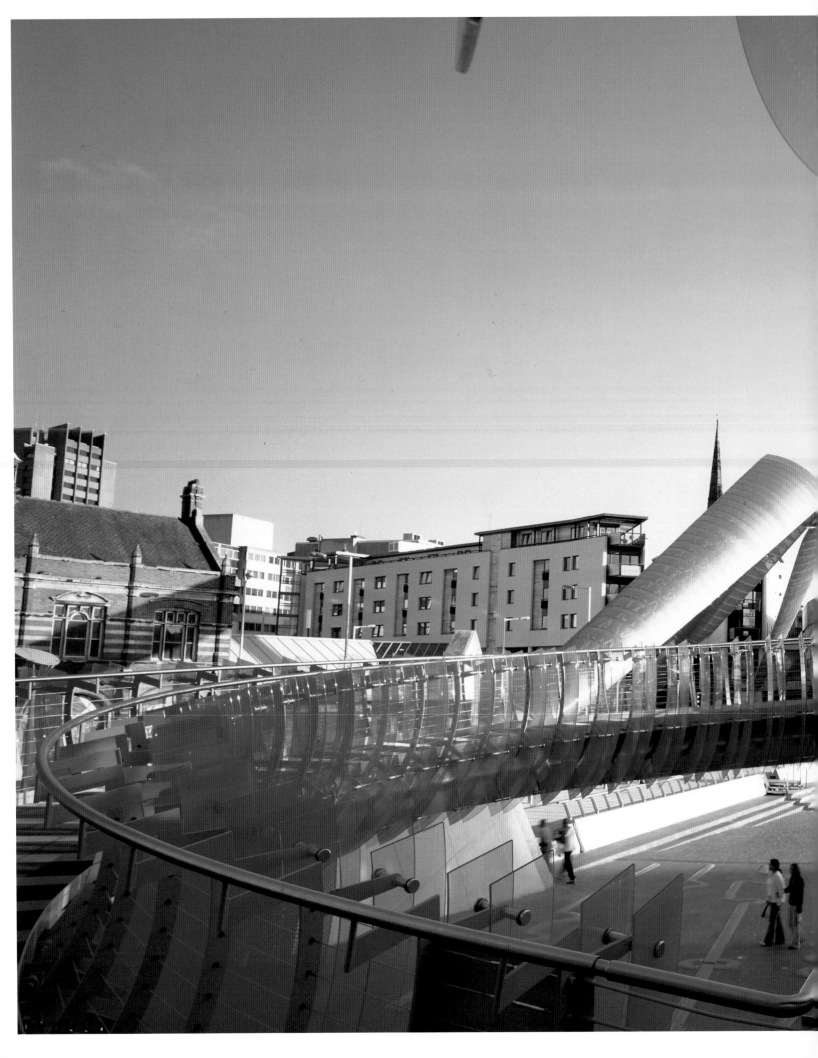

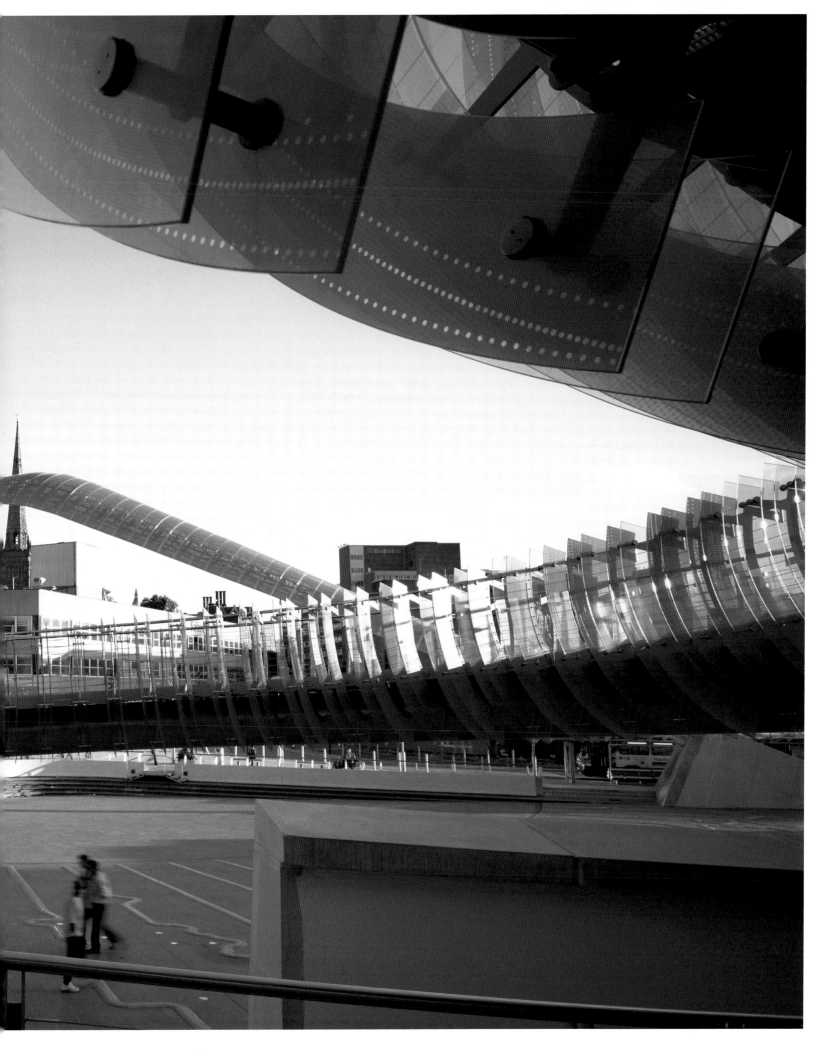

MJP with Whitbybird, Whittle
Arch, 2003, view revealing
anthropomorphic structure
beneath its perforated
stainless steel skin.
Photo Marc Goodwin.

THE WHITTLE ARCH

Providing a physical connection to Priory Place and giving height and prominence to Millennium Place, the 15 metre high Whittle Arch, designed by MJP and engineer Whitbybird, springs over the space as paired arches that 'kiss' at their apex. The arch is named after Frank Whittle, the inventor of the jet engine in Coventry's Rolls Royce factory.

This structure forms a metaphorical gateway to the twenty-first century, to which Millennium Place is dedicated, and bridges the historical River Sherbourne which is culverted below the site and is identified in an area of blue paving.

The open structure is made of connected oval steel plates separated and braced by steel structural rods. Clad in perforated stainless steel, it is softly washed with blue light, from metal halide narrow beam projectors with blue glass filters at the four bases. It is also internally lit with amber LED fittings anchored in the plates, which illuminate the internal structure of the arch, reinforcing the impression of transparency.

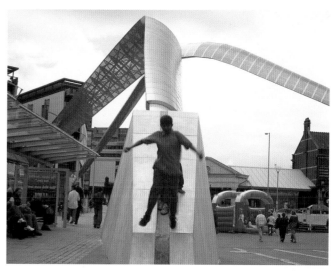

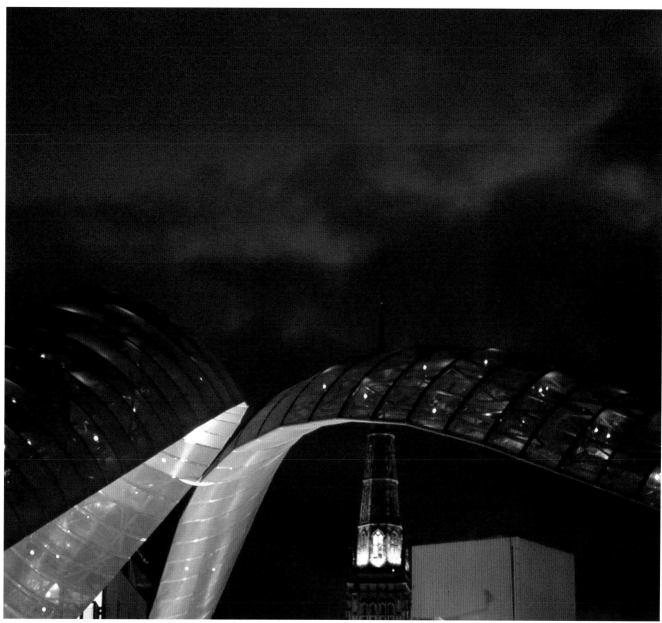

Above: MJP with Whitbybird, Whittle Arch, 2003, detail of arch base. Photo Marc Goodwin.

Below: MJP with Whitbybird, Whittle Arch, 2003, night view showing amber LED's illuminating the interior of the arch – lighting by Speirs and Major. Photo Michael Rummey, RDA.

MJP, Coventry Transport
Museum, 2004, night view
of entrance with Françoise
Schein's *Time Zone Clock*
and the glass bridge and
ramp in the foreground.
Photo Marc Goodwin.

COVENTRY TRANSPORT MUSEUM

The refurbishment of the Coventry Transport Museum by MJP has provided additional galleries and much improved visitor facilities. The most dramatic change is the new frontage to the museum facing Millennium Place, bringing the museum into the heart of the city. An eight metre high glazed wall onto Millennium Place defines a new double height entrance. A projecting louvred canopy which emerges through the glass marks the discreet entrance.

Inside, the new façade opens out onto a large temporary exhibition space and a new museum shop. Four new galleries have been added to the existing displays making it the largest motor museum in the UK.

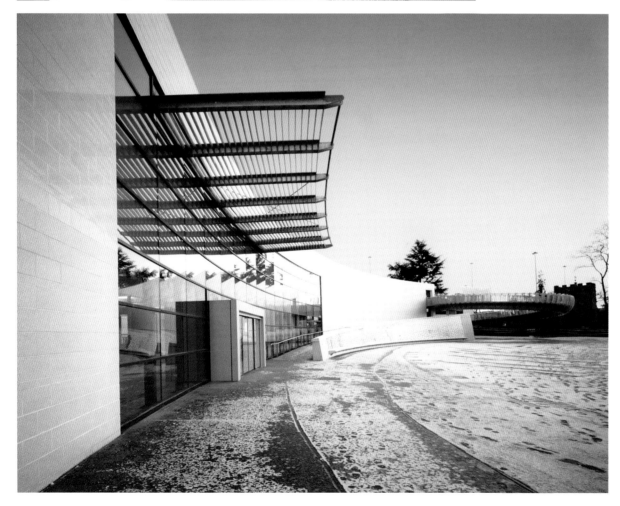

Above: MJP, Coventry Transport Museum, 2004, view of double height entrance area. Photo Marc Goodwin.

Below: MJP, Coventry Transport Museum, 2004, entrance portico and canopy looking west. Photo Marc Goodwin.

TIME ZONE CLOCK
FRANÇOISE SCHEIN

Time Zone Clock celebrates the human invention of political and geographical time boundaries, divided into 24 sequences. Before the invention in 1884, every country (and in some case individual cities) had its own time system, making it increasingly complicated to travel. The concept of time zones has always attracted me because it facilitated human understanding by equalising time between people, which was a significant democratic move.

It seemed appropriate to me, given the Millennium and the fact that the time zone system was invented in Britain, to present an idea related to the concept of time. In addition, Coventry has an important history of industrial clock and watch-making, and a collection of sister cities from around the globe. Millennium Place presented a perfect site to explore these ideas.

I first used the time zone concept for a proposal in 1985 when I was approached to create an installation for a building in the World Trade Centre complex. I returned to this idea for Coventry where, in retrospect, the links between Coventry and New York seem resonant and illuminating to me, given Coventry's experiences during the Second World War.

Françoise Schein, Proposal for *Time Zone Clock* and Millennium Place, 1998. Photo Françoise Schein.

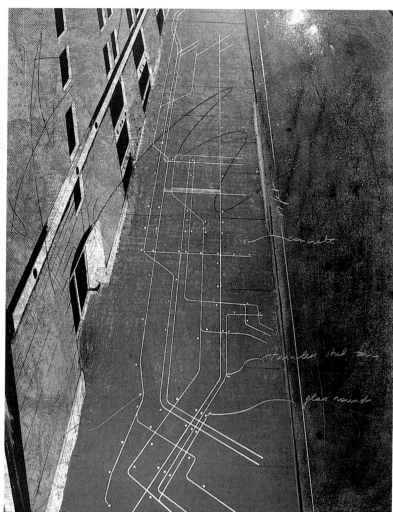

Clockwise from top left:
Françoise Schein, Concorde
Metro Station, 1990-1991,
Paris. Photo Françoise Schein.

Françoise Schein, Subway
Map floating on a New York
Sidewalk, 1985-1986. Photo
Françoise Schein.

Françoise Schein,
Parques Metro Station,
1995-1997, Lisbon.
Photo Françoise Schein.

Françoise Schein, Gulliver's
Travels, 1997, unrealised
proposal for North
Greenwich Tube Station,
commissioned by PACA.
Photo Françoise Schein.

PUBLIC BENCH
JOCHEN GERZ

The citizens of Coventry and visitors to the city were invited to give their name together with another name and a date of their choice. This information was then printed onto a red acrylic plaque and mounted on a 45 metre long bench. The bench maintains its primary function without any limitations or alterations. People are able to become part of the project at any stage (while there is still space).

The reasons for the choice, as well as the identity of the names, will not be revealed. The second name can belong to a living or a dead person. It can also recall a fictitious figure from a novel, a myth, a dream or a fairy tale. In order to understand each couple's inscription more fully one has to contribute oneself. Only then do personal priorities become clear. Emotions such as sympathy, admiration, support and, above all, love, will determine many choices. The contribution is one person's choice. It does not need anyone else's approval.

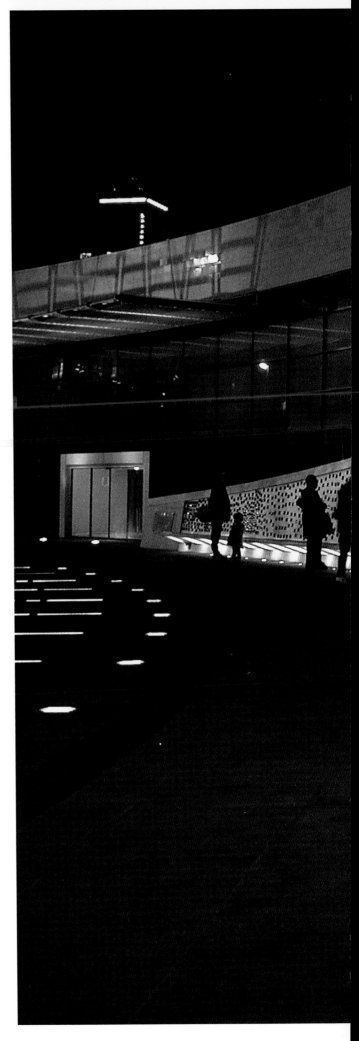

Jochen Gerz, *Public Bench*, 1998-2003. Photo Michael Rummey, RDA.

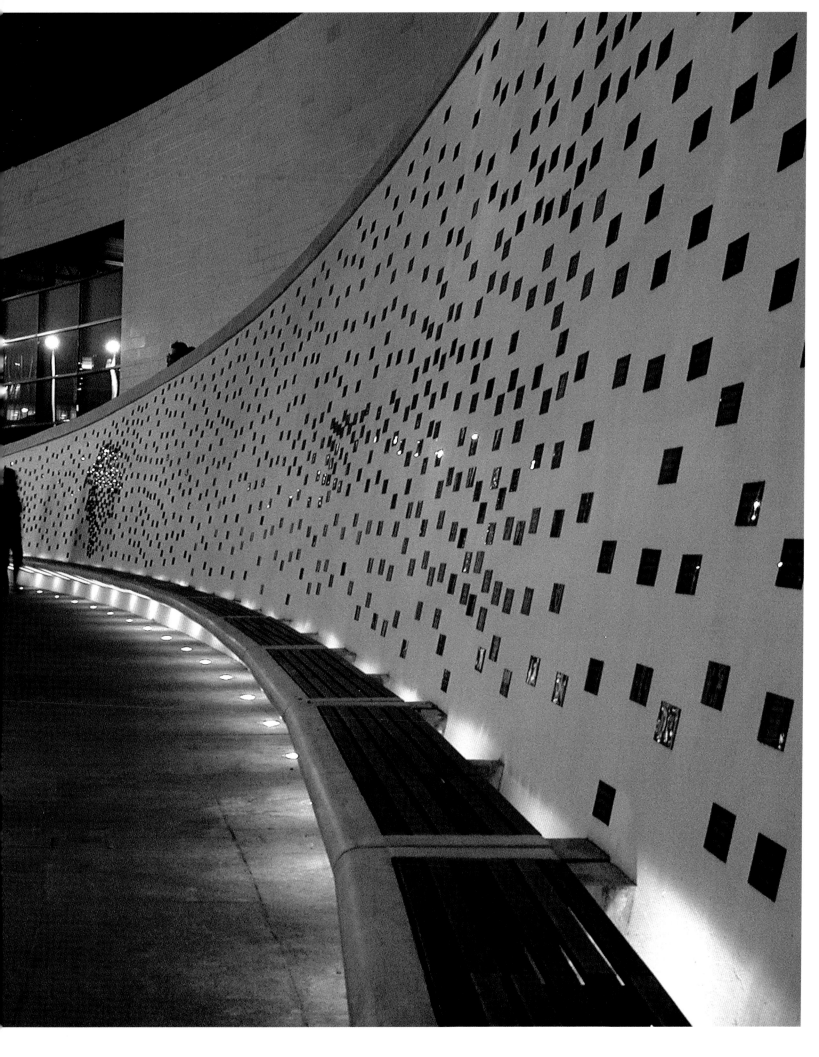

Jochen Gerz, *Future
Monument*, 1998-2003.
Some of the many
communities in Coventry
with whom Gerz collaborated
on this project. Photos Olivia
Morel-Bransbourg and
Jochen Gerz.

FUTURE MONUMENT
JOCHEN GERZ

The idea behind this monument is one of tolerance and reconciliation, peace and change. As often the enemies of the past become, over time, the friends of today, the project addresses the taboo of issues like history and the necessary infidelities of memory. People were asked to name the nations who were enemies of their country in the past and are now its friends. Over 60 countries were nominated and the process is ongoing.

Future Monument approaches the members of the different communities of the city equally, and through the resulting answers one can comprehend the constituency of the population today. The results of this 'poll' give voice to the hidden parts of the city and of the public mind.

As a second part of the work, each group, community or organisation coming forward with 40 signatures will have their plaque installed behind *Future Monument*. These plaques show how exotic and unexpected the minorities are that constitute society today.

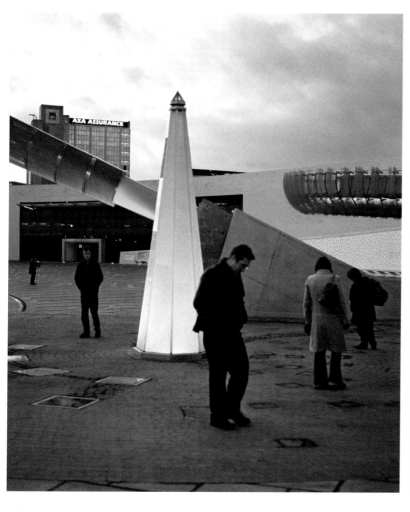

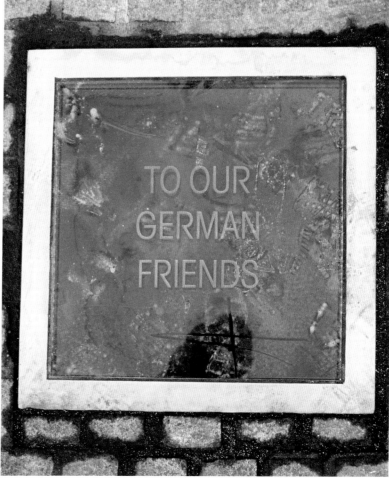

Left: Jochen Gerz, *Future Monument*. Photo Jochen Gerz.

Right: Jochen Gerz, *Future Monument,* detail, 1998-2003. Photo Jochen Gerz.

GLASS BRIDGE

A ramp rising behind *Public Bench* provides access to a dramatic cantilevered spiral ramp that rises up to the glass bridge. Lined with over 800 glass fins, screen-printed to the designs of artist Alexander Beleschenko, the bridge flies over the listed Lady Herbert's Garden and the last remaining section of the fourteenth century city wall, to land in the new Garden of International Friendship. Inspired by the idea of ribbons, the glass design is a dynamic feature as it weaves through the tree tops.

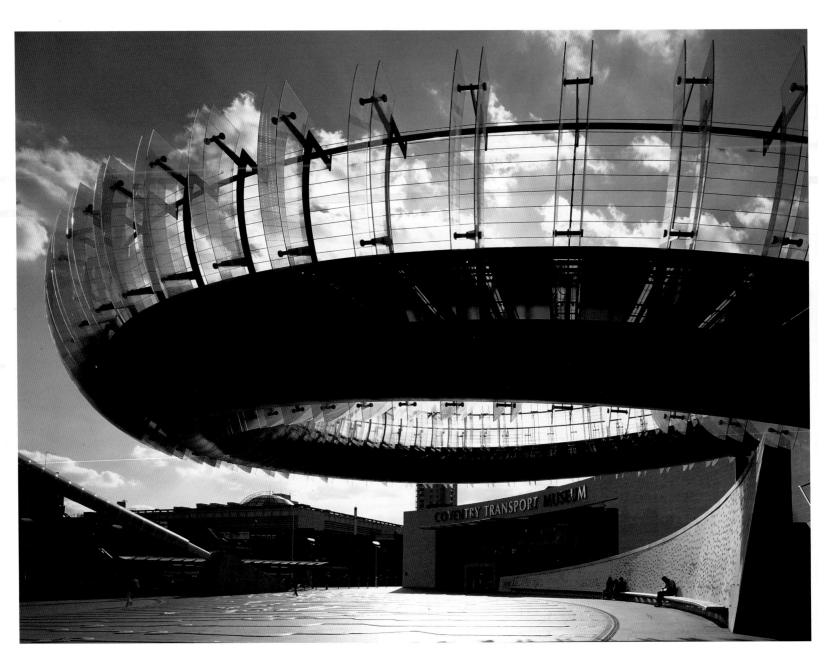

MJP and Whitbybird with Alexander Beleschenko, The Glass Bridge, 2003, the cantilevered spiral ramp that leads to the bridge. Photo Marc Goodwin.

ALEXANDER BELESCHENKO
I wanted to make something that worked with both the architecture of the bridge and the expanse of the sky. My thinking revolved around how to incorporate temporality, the ethereal and the unpredictable into such a permanent and necessarily robust and stable structure.

Initially I designed long, curved, undulating glass walls which followed the lines of the bridge. For a mixture of technical and aesthetic reasons I began to consider how, by working with smaller sections of flat glass at a different angle, I could devise a relatively simple shape and system that would produce great subtlety and variation.

The shift from the snaking ribbon to the fin structure was a move from skin to ribs and it added complexity to the visual aspect. As you walk past the glass or scan along a length of the bridge your eye moves from edges to the face of the glass to viewing many layers. At some angles the steel structure becomes invisible, altogether dissolved and absorbed by the glass. These are the kinds of things that one cannot entirely predict, working on this kind of scale. Such effects are speculated and imagined at the design stage but only known when all the elements are brought together on site.

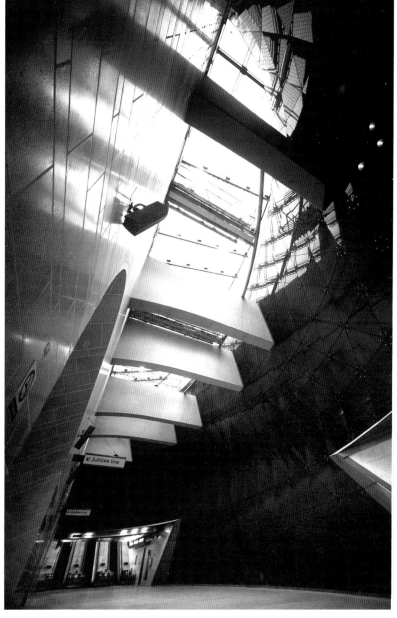

Left: Alexander Beleschenko, *Glass Screens*, 1992-1993, commissioned by PACA for The Garden Quadrangle, St John's College, Oxford, designed by MJP Architects. Photo Peter Durant/Arcblue.com.

Right: Alexander Beleschenko, *Blue Glass Wall*, 1999, Southwark Undergound Station, London, designed by MJP Architects. Photo Peter Durant/Arcblue.com.

Each fin is industrially screen-printed with a gradation, from the faintest mist to a dense solidity of enamel dots, subsequently fired permanently onto the glass surface. The screens printed the finest dot possible: I wanted to work with the most delicate detail, in contrast to the large scale and power of the bridge. To order the eight hundred plus fins with eight different patterns of gradation I used a random method, trusting that chance, especially on such a scale, produces its own balance and logic and beauty. As has been observed in nature, you never see poor composition in a field of wild flowers. This produced a huge amount of play in the visual and spatial rhythm.

Blue was chosen, most obviously to connect with the sky, but also for its particular visual properties. From a distance things appear more blue: it is the colour of distance and of the spaces beyond us.

It was important that the glass would work as effectively with daylight as with the dramatic artificial nighttime lighting. Glass catches and transmits light and that to work with glass is to work with light. The glass ties the bridge to its wider environment and to time, as the sunlight moves around the spiral.

The bridge itself appears to float and the glass seems to dematerialise it and to render it weightless. The apparently fragile material articulates the bridge. It appears like the joints of the curve, like reptilian vertebrae; it emphasises its shape but I hoped too that it would give voice to the bridge and let it sing like the ring of glass.

Left: MJP and Whitbybird with Alexander Beleschenko, The Glass Bridge, 2003, the spiral ramp at night with lighting by Speirs and Major. Photo Marc Goodwin.

Right: MJP and Whitbybird with Alexander Beleschenko, The Glass Bridge, 2003, the bridge spanning Lady Herbert's Garden and the old city walls. Photo Marc Goodwin.

Opposite: Alexander Beleschenko, The Glass Bridge, detail of glass fins, project realised with MJP and Whitbybird, 1998-2003. Photo Marc Goodwin.

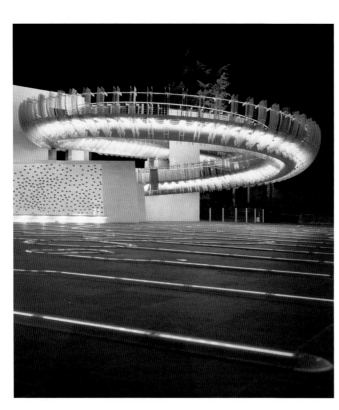

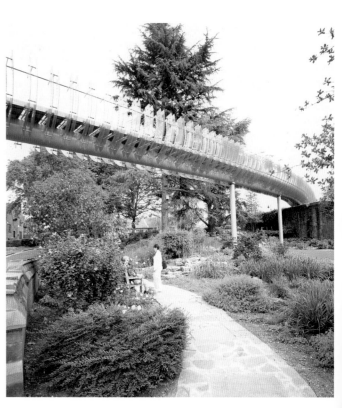

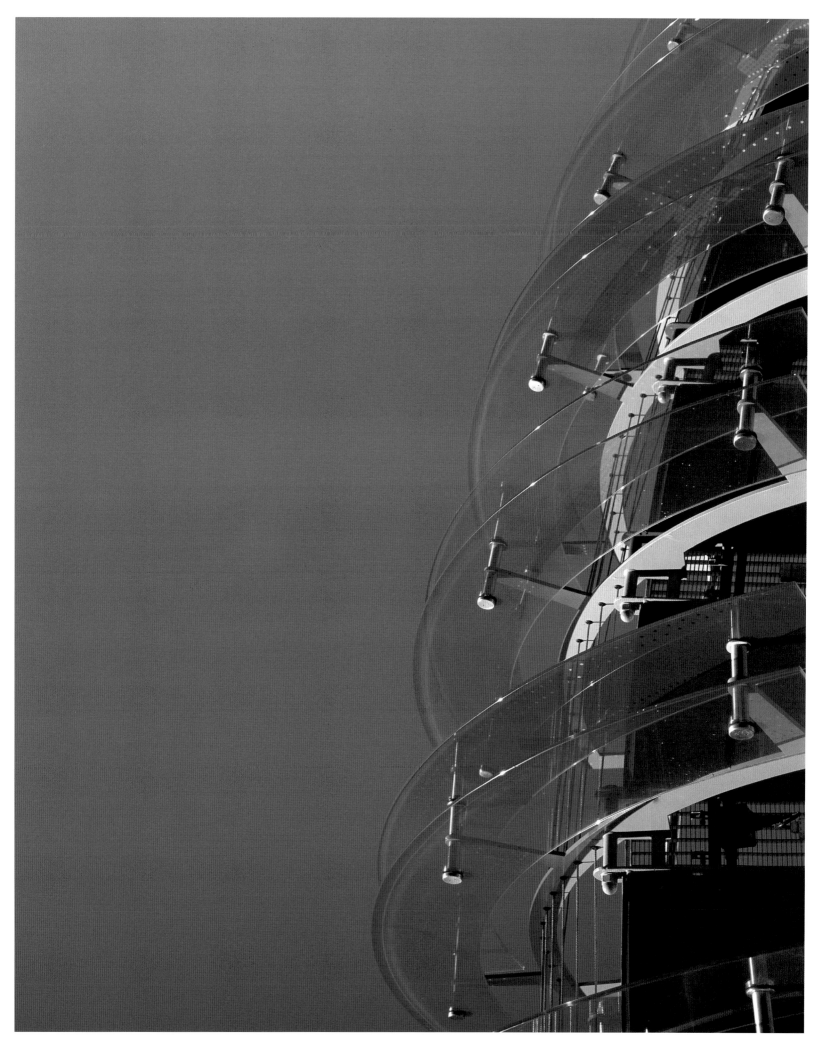

THE GARDEN OF INTERNATIONAL FRIENDSHIP

Set between the Edwardian Lady Herbert's Garden and the ring road, this new garden, designed by Rummey Design Associates, with Kate Whiteford, recognises Coventry's important role as a centre for international peace and reconciliation. The design seeks to reconcile its own position between the ring road, the older garden and as the termination of the Phoenix route through a combination of earth works, architecture and planting. Incorporating an earlier 1970s scheme for landscaping the area under the ring road, it created

a seamless connection with the city beyond. Earthworks and sandstone walls are used to raise levels to receive the glass bridge without compromising pedestrian routes through the site, and providing gentle ramped access to the bridge. Walls are designed to turn the viewers' attention back up the site to the cathedral and the start of the journey.

Looking in the other direction a curved wall facing the ring road defines the edge of the sunken garden, an artwork by Kate Whiteford

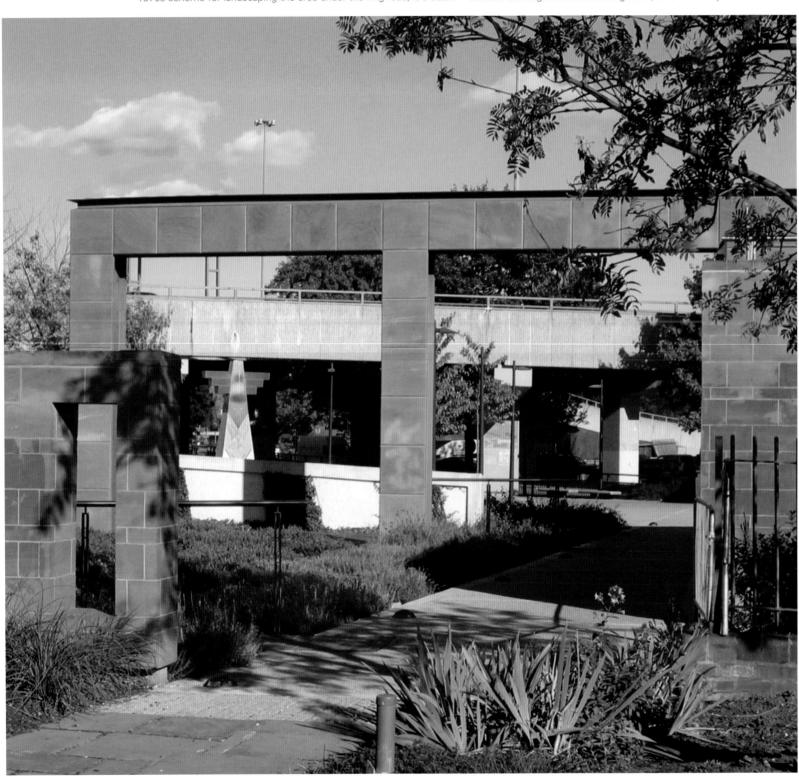

RDA with Kate Whiteford,
The Garden of International
Friendship, 2001. Photo
Robert Rummey, RDA.

based on a maze inspired by the pattern on a medieval floor tile and recalling the orchards and gardens that were situated outside the city walls in medieval times.

The top of the curved wall has an inset bronze text extracted from the Coventry Mystery Plays, by poet David Morley.

RDA with Kate Whiteford,
The Garden of International
Friendship, 2001.
Photo Marc Goodwin.

PRIORY MAZE
KATE WHITEFORD

The land drawing *Priory Maze* engages both historical fact and poetic fiction. In an inner city setting this new sunken garden is an interactive space planted with contrasting box hedging and white gravel, to form a section of a maze, best viewed from the new glass bridge which drops down into the garden, or from the inner ring road which soars overhead.

In this urban setting the sunken garden reveals layers of cultural history which surprises, given the funky urban setting. By making reference to the great maze of Chartres Cathedral I made a deliberate visual link with the network of European cathedrals and laid out a section of a maze, as though recently 'excavated' from the surrounding urban highways. The twists and turns of the maze also echo the many ropeworks that were part of a once significant industry in the area.

The garden is intended to have a dynamic intervention with the surroundings. It can be enjoyed as a playful interactive space. It should also provide a place for reflection, to encourage visitors to remember the wider history of the area – not only the terrible devastation of the Second World War and its aftermath, but also the peaceful contemplative life of its monastic past. The *Priory Maze* uses a poetic metaphor to rediscover the rich cultural and contemplative history of the site and the city's links with the great cultural centres of Europe.

A child in Kate Whiteford's Maze within the Garden of International Friendship, 1998-2001. Photo Kate Whiteford.

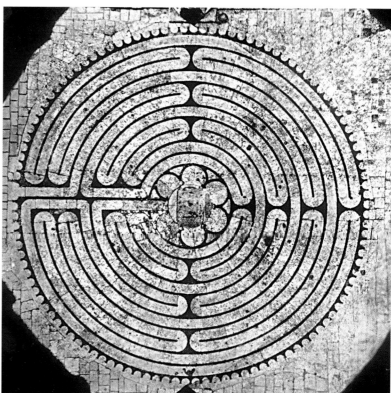

Above left: Kate Whiteford, One of a series of designs for the Maze in the Garden of International Friendship, 1998-2001. Photo Kate Whiteford.

Above right: Kate Whiteford, Image of Maze from Chartres Cathedral, preparatory research for Phoenix Initiative, Garden of International Friendship, 1998-2001. Photo Kate Whiteford.

Above: Kate Whiteford, *Sculpture for Calton Hill*, 1987, land drawing, Calton Hill, Edinburgh, commissioned by TSWA. Photo Kate Whiteford.

DAVID MORLEY, POET
The text embedded in the top of the curved retaining wall in the Garden of International Friendship quotes from the renowned Coventry Mystery Plays, which would have been performed by processions of local people around the city gates.

David Morley also compiled two (*Phoenix New Writing* and *Ludus Coventriae*) collections of writing during the period of the Phoenix exploring themes of Coventry's past, present and future. Phoenix New Writing arises out of the University of Warwick Writing Programme's involvement in the city's Phoenix Initiative project, and from the complementary work that took place in both the universities of Coventry and of Warwick with students, schoolchildren and writers from many Midlands communities.

PROCESSIONAL

UNWALLED COVENTRIE
WITHINNE NO WALL,COME YOU NOT
BE ONCE YOU WITHINNE THIS FAIR CITÉ'S GATE
THE PEPYL TO PLESE WITH PLAYS FUL GLAD

WE SHALL SHEWE AS THAT WE KAN
HOW THAT THIS WERD FFYRST BEGANAN
D IN THIS GARDEYN WYL THOU GO SEE
ALLE THE FFLOURES OF FAYR BEWTIE
AND TASTYN THE FRUTES OF GRET PLENTIE
THAT BE IN PARADYSE

O SISTERS TOO
HOW MAY WE DO
FOR TO PRESERVE THIS DAY
THIS PORE YONGLING
FOR WHOM WE DO SINGE
BY BY, LULLY LULLAY
DOUNE FROM HEAVEN
FROM HEAVEN SO HIE
OF ANGELES THER CAME A GREAT COMPANIE
WITH MIRTHE AND JOY AND GREAT SOLEMNITYE
THEY SANG TERLI TERLOW
SO MERELI THE SHEPPARDS THER PIPES CAN BLOW
LULLY, LULLA, THOW LITTLE TYNY CHILD
BY BY, LULLY LULLAY,
THOW LITTLE TYNY CHILD

OWT OF DESERTE, FROM THE HARD STONE
I EXORTE YOU ALL
THAT IN THIS PLACE ASSEMBULDE BE
WITH SUN, MONE AND STARIS
ERTHE, SKY AND WATTUR
AND AL FOR THE SUSTENANCE OF OWRE HUMAYNE NATURE
WITH FYSCHE, FOWLE, BEAST
AND EYUERE OTHUR THYNG VNDER US
TO HAVE THE NATURALL COURSE AND BEYNG
THATT THE MYRTHE THEROFF CAN NOO LONG TELL
NOR HAND WITH PEN SUBSCRYBE

FEYTHEFULL FRYNDE AND LOVE DERE!
TO YOU THIS TEXT OFTE HAVE I TOLDE
THATT OWT OF DANGYR
SCHALL US RELEASE

Opposite: David Morley,
text selected from the
Coventry Mystery Plays for
the Phoenix Initiative
installed within the Garden
of International Friendship,
2003. Photo Marc Goodwin.

Following pages: Kate
Whiteford with RDA,
The Maze in the Garden
of International Friendship
at night, 1998-2001.
Photo Kate Whiteford.

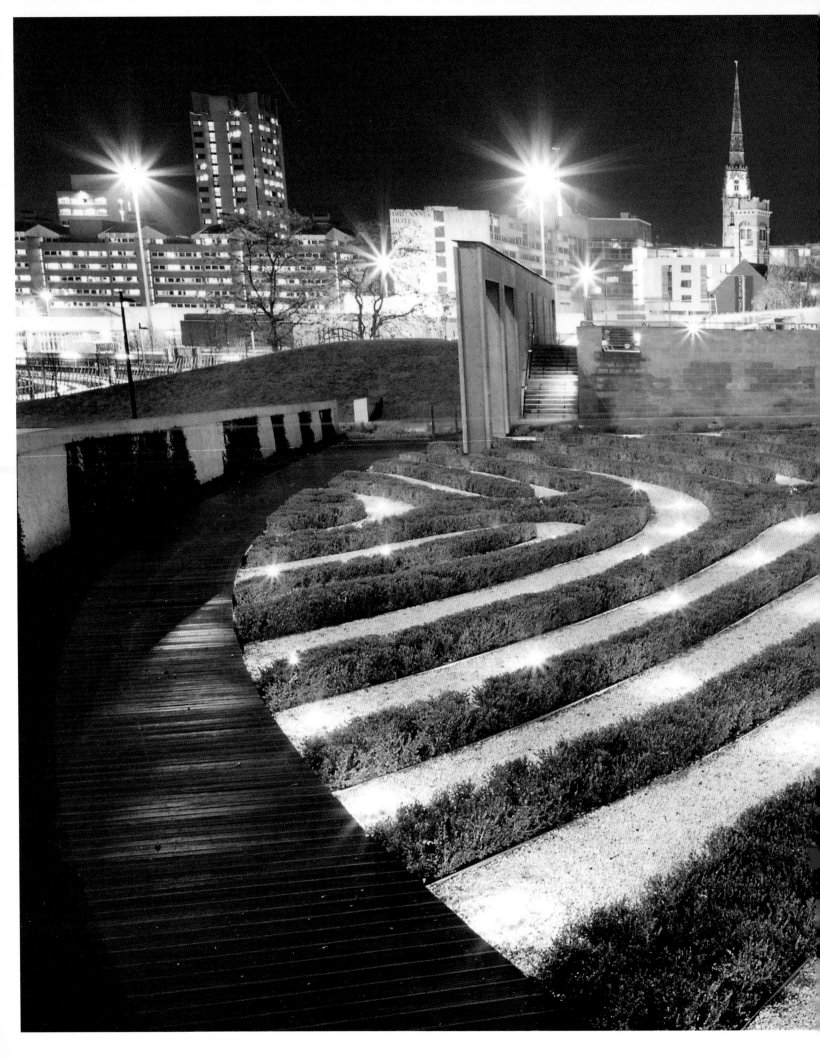

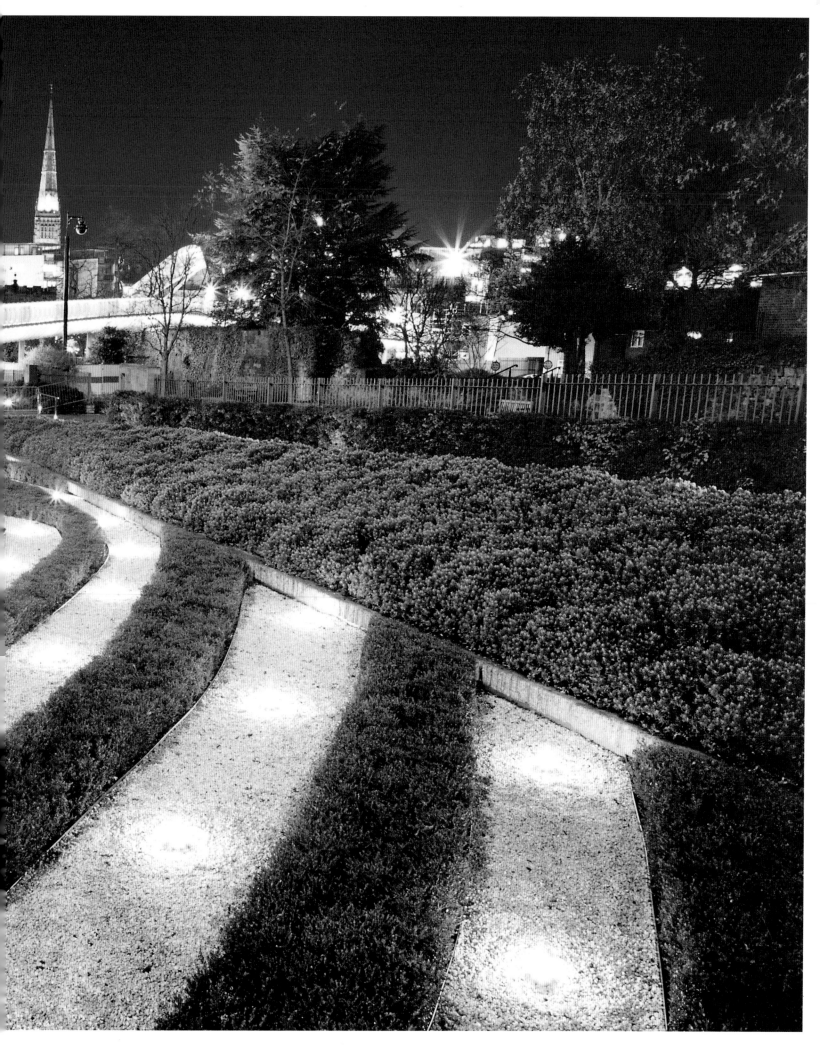

A STRANGER WITH SECRETS: JOCHEN GERZ, FUTURE MONUMENT, PUBLIC BENCH

SARAH WILSON

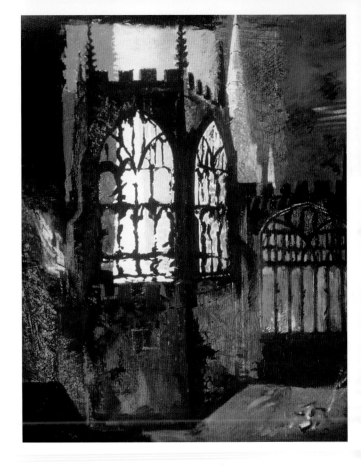

John Piper, *Coventry Cathedral*, 1940. Courtesy Courtauld Institute.

The Phoenix initiative's choice of Jochen Gerz to work alongside other artists in Coventry is particularly appropriate. While renewal and regeneration have been achieved in Millennium Place through the 'shock of the new' – the concept of Coventry, "City of the Future" – with its arching glass bridge and Françoise Schein's *Time Zone Clock*, Gerz's twinned projects, *Public Bench* and *Future Monument*, have a deep link to Coventry's role as a 'site of memory'. As England's first bombed city, Coventry takes its place in an international network of sites marked by the dialectic between ruin and pain, reconstruction and reconciliation.[1] While Gerz's works are exemplary public commissions in terms of their consultative processes, and as 'public art' involving 'public authorship' they symbolise transnational, personal, and indeed private stories; stories of the anonymous and the disappeared which will never be known.[2] At the moment of inauguration and at a time of Britain's involvement in new wars, his complex project, with its historic roots in post war Germany, deserves further consideration.

Jochen Gerz was born in Berlin on 4 April, 1940. On 25 August, the first German bomb fell in Fore Street, in the City of London; on 14 November, the centre of the city of Coventry was largely reduced to rubble. Winston Churchill declared: "those who have loosed these horrors upon mankind will now in their homes and persons feel the shattering strokes of just retribution".[2] Dresden, Frankfurt, Cologne's medieval cathedral and Berlin were subsequently bombed: the cityscapes of Germany were no more.

Gerz, too, was a child of the rubble: "You walked differently, you thought differently, you could walk through houses, you had a double city, you could know it better than the police...."[3] And for Gerz, Coventry, with its heritage of bombing and reconstruction, has always been the most German of English cities, "a defeated place in a victorious country". The Community of the Cross of Nails would soon present crosses of nails to Kiel, Dresden and Berlin.[4] On my last visit, a wreath from Bremen was laid on the altar of the old cathedral, under the cross made of two charred beams. This is indeed a special relationship.

Coventry was Britain's beacon city in the post war years. Together with its mission of reconciliation went the extraordinary artistic effort, celebrated worldwide, that culminated in the consecration of the new Coventry Cathedral. It involved the very same War Artists who had rushed to the bombsite. The Gothic spirit of John Piper's *Interior, Coventry Cathedral,* 1940, echoed the ruins depicted; his chiaroscuro purposely evoked Blake, the illustrator of Milton's *Paradise Lost*: "No light but rather darkness visible." While English neo-Romanticism looked nostalgically to the past, its dark other was the up-to-date blitz technology of the V2 rocket, and the future atom bomb.

As Coventry made gestures towards Dresden and Hiroshima in the post war period, its rising cathedral expressed a new modernism, a renewed humanism, embellished by Piper's now abstract baptistery stained glass windows, Graham Sutherland's now hieratic, neo-Byzantine style tapestry *Christ in Glory*.[5] It was Ralph Beyer who carved in primitive lettering the messages on the eight great tablets of stone that rhythm the nave: "A New Covenant will I give unto you that ye love one another as I have loved you."[6] So Jochen Gerz is not the first artist of German descent to contribute to Coventry's heritage. Nor as he points out, were the Germans the first to raze its ecclesiastical fabric: Henry VIII was responsible for the complete physical destruction of Leofric's medieval monastery, not to mention the intellectual network across Europe that it represented.

Public sculpture in Coventry has always defined moments and styles of the city's history. In the ruined precincts of the old cathedral, Hamo Thorneycroft's elaborate Edwardian effigy in bronze of Huyshe Wolcott Yeatman-Biggs, first bishop of the revived See of Coventry, 1924, contrasts with Jacob Epstein's carved white marble *Ecce Homo*, 1934-35, and Josefina de Vasconcellos's kneeling pair, *Reconciliation*, 1995, offered by Richard Branson to Coventry and the Peace Garden, Hiroshima. Gerz's *Public Bench* and *Future Monument* are radically different, set in the downtown venue of Millennium Place, facing the old Fire Station and Sainsbury's, not the hallowed ruins where the Litany of Reconciliation is recited each Friday at noon: "The hatred which divides nation from nation, race from race, class from class Father forgive."

Jochen Gerz, Proposal for
Future Monument, 2003.
Photo Jochen Gerz.

For many years – 1998-2004 – Jochen Gerz took planes by night and day from Paris and other European capitals to Coventry; he laughed and joked with the lofty and the most ordinary townspeople. His mission was to convince the sceptics that his monuments – unlike any notion of sculpture they had previously encountered – were not only feasible but sustainable in a potentially hostile environment. Before and after 11 September 2001, Gerz pursued his goal. "New York a new Coventry", declared London's *Evening Standard* at the time, illustrating the Twin Towers' destruction with a view through more neo-gothic tracery and twisted girders: that helped at a moment when the question behind *Future Monument* "Who are the enemies of the past?" ("the hatred which divides nation from nation...") was deemed most dangerous.[7]

The genesis of *Future Monument* goes back as far as 1993 when Gerz was strolling through Manchester (his installation *A Sense of Attention* was in the City Art Gallery).[8] He noted at the foot of the city war memorial a plaque inscribed "To our Italian comrades". Learning that the site was to be redeveloped, he made two rough sketches for a *War and Peace Monument*. The first, surrounding the original obelisk with plaques dedicated to seven nations, was marked "Former enemies – friends"; the second, "Communities, Mental communities, Nation, Race, Identity, Religion, Class, Inclusion/exclusion, Language: in another language, Typographie".[9] "Mental communities"? Instantly, one recalls Benedict Anderson's important work on questions of nationalism first published in 1983 as *Imagined Communities*.[10] Gerz was already experimenting with the paradoxical contrast between obelisk, stone, inscription, and the volatile, immaterial worlds of personal and political emotions.

So *Future Monument* conceived for Coventry in 1998 had a complex British past. Today, the glass plaque set beside the obelisk proclaims: "The Future Monument is an answer from Coventry's inhabitants to the city's long and often dramatic past. It deals with former enemies becoming friends. Over 5,000 citizens contributed to the artwork. This is a public as well as a personal statement and the city council wishes to thank the many Coventrians from other countries who have participated, joining their own memory to the city's history

in an endeavour for peace and reconciliation. 40 signatures were needed for a group or minority to be offered a plaque behind the obelisk to celebrate the diversity of Coventry's present day population."

Looking towards Lady Herbert's Garden we see plaques at the foot of the obelisks which read:
To our German friends
To our Spanish friends
To our Russian friends
To our American friends
To our British friends
To our French friends
To our Turkish friends.

Facing the town we see below the obelisk a more irregular scattering of plaques, illuminated from below by night, as is the needle itself: a soft luminescence shining through its layers of fractured glass, "fragile and dangerous".[11] The groups represented mark a coming together of various communities across time and space. Surely certain societies must date from the 1930s at least: the Coventry Women's Horticultural Society, the Cyclists, Scouts and Netball players. The revivalist Godiva Sisters – who annually celebrate Lady Godiva's feast-day – epitomise recent "inventions of tradition". The Jewish, Irish, Greek Orthodox and Barbadian communities represented here must have established themselves in Coventry over the years. Many different Asian groups have more recent origins: the Indian Ladies Cultural Association, the Shree Krishna Temple, or the Mrittika Arts Dance Troupe. "To our British friends"? With the most extraordinary discretion, this plaque evokes the centuries-long, so often brutal story of Britian's colonial past and today's multi-cultural society. (Gerz has long been fascinated by the tale of the Trojan horse: this provocative message, 'authored' by the local population, is the critical fulcrum of *Future Monument*).

The changes through time of Coventry's population are also visible in the scattering of red plaques across the great curvilinear sweep of *Public Bench* – "freckles on the cheeks of the city" as one good lady put it.[12] At the beginning of the curve an engraved glass plate

reads: "Do you have a friend? Since 1999 the people of Coventry and visitors to the city have commemorated a friendship, as secret relationship or a memorable encounter. The invitation for everyone to contribute to the public bench continues until this space is covered with plaques."

The chosen people could be from Coventry or not, alive or dead, real or fiction. "Mary Fearon and Margaret Spencer 05-04-1916" included the earliest date I saw; many dates surely commemorated engagements or marriages: "Frederick Metlalfe, Margaret Metlalfe, 14-12-1924". Are "Harjinder Dehal and Teja Singh 30-10-2002" recent lovers or simply an on-the-spot decision by two friends to participate in the project? Are we dealing with Coventrians or visitors? "Coriena Brierley, Slavica Stojsavljevic 08-09-2002"; is Slavica a resident or tourist from the 'new' Europe (the old Europe before the divisions of the Second World War)? Coventry's history of reconciliation is epitomised by the plaque which bears the names Ron Jordan and Georg-Wilhelm Schulz, one the 19 year old victim of a U-boat torpedo, in 1942, one, the boat's previous captain. 'Brother marks kindness of former enemy' declared the *Coventry Evening Telegraph*. This reportage is not merely 'newsworthy' but a vital supplement to Gerz's project, an alternative archive, a transmission living memory to thousands.[13]

One particular conjunction ,"Irina Ratushinskaya, Gordana Antolovic 10-09-03" bears the symbolic date of Lady Godiva's day. The *Coventry Evening Telegraph* recounts how the dissident Soviet poet, Irina Ratushinksaya, wrote a tribute to Lady Godiva amidst the despair and brutality of a Siberian labour camp in January 1985. ("How little I know of you, Golden-maned lady...") Gordana, now resident in Britain, translated her own poem about bombing during the 1991 war in Croatia into English, dedicated it to Ratushinksaya, and organised this conjunction of experiences, of time, of countries, wars and of three languages – all condensed into a cryptic inscription on *Public Bench*.[14]

"An engaging personality" was the consensus on the artist at the Warwick University conference of November 2003; but very few

were aware who Gerz might be, nor – even when he talked and illustrated his most celebrated projects, the Harburg *Monument against Fascism*, 1986, and the Saarbrücken *2146 Stones. Monument against Racism*, 1993, that here was one who had a much longer and richer relationship with Britain than any in Coventry might guess.

Gerz is certainly the most important artist from Germany to make a permanent work in this country since Kurt Schwitters, whose Merzbarn was created in the Lake District in the wake of the artist's experiences of London's Blitz. Schwitters' artistic adventure began with the Dada movement in the nihilistic aftermath of the First World War; he witnessed with foreboding the rise of fascism in Europe from the late 1920s onwards, then modernism shattered, its hopes and cities bombed to pieces – its shards reamassed as he continued to work almost alone, with extraordinary courage and hope in the 1940s. Like Schwitters, Gerz's work has a Dada heritage; he is a master of the sign; he writes poetry extensively in English and is fascinated by our vernacular. And just as the bus ticket or the advertising jingle entered Schwitters' collages, so the world of popular culture and its friction with the world of art is a constant catalyst for Gerz.

But T S Eliot, Ezra Pound and e e cummings were the mentors who trained Gerz's English ear, as he moved from translation to typographical experiment and the world of concrete poetry in the 1960s.[15] For Gerz is not a sculptor but a poet; he has been a jazz pianist, former London taxi driver and sports correspondent (his *Empty Plinth* proposed for Trafalgar Square in 1996 is a hommage to British football). He began writing in poems and prose in 1958 and studied German and English literature, along with Chinese civilisation at the University of Cologne, where he became aware of the Dusseldorf-based Zero Group, Yves Klein and Fluxus. Then, at the moment of the refounding of the German army and compulsory military service, Gerz absconded to London in 1960. He discovered an austerity London just blossoming into the 60s, with a vital poetry scene that extended through Blake revivals to the Beatles, with major festivals at venues like the Royal Albert Hall or the Roundhouse, Chalk Farm.[16] Here Gerz worked in a bar – and distributed the

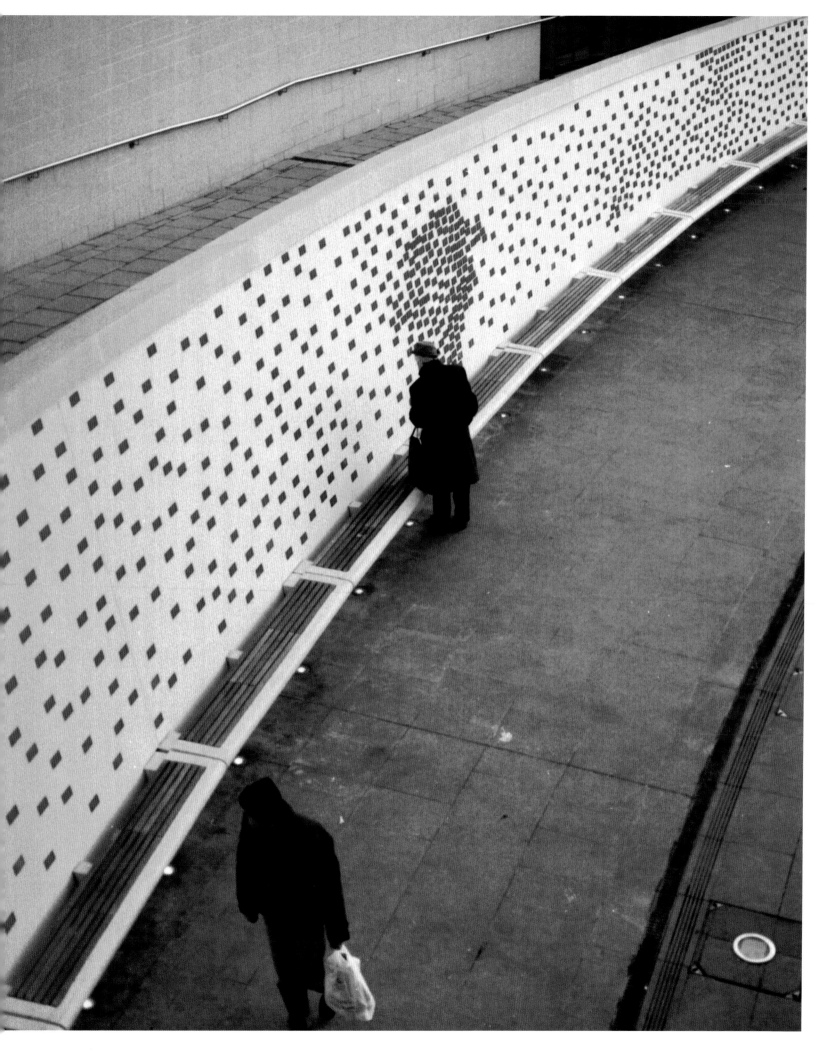

Evening Standard; his taste for newspapers developed as he translated sports results; his taxi experiences extended mental networks of city peoples and topographies.

Returning to Cologne, he subsequently went to live in Basel, Switzerland, where he officially studied prehistory. Here he encountered the philosophers Karl Jaspers and Martin Heidegger, artistic circles around Max Bill and Richard Lohse, and worked for the publicity agency which organised John Cage events in the city. Cage, rather than Marcel Duchamp was surely a paragon for Gerz at this time, with his ethos of life, art and the environment as a continuum. When his wife won a grant to Paris the couple decamped: Gerz found himself in a far larger, cosmpolitan capital, conscious of its Dada and Surrealist heritage with a visual and sound poetry and experimental music scene. The anti-'art' Situationists, with their concept of *détournement* – swerving away from the norm, perverting the expected – were particularly striking for Gerz, just when Paris itself became a living poem of their posters, slogans and graffiti in May '68.

"Art corrupts" was the motto on stickers which Gerz flyposted on the cathedral doors and the pedestal of Michaelanglo's *David* in Florence in June, 1968 – direct precursors of the red plaques on Coventry's *Public Bench*.[17] And in September, 1968, his first city monument was envisaged. Nothing less grandiose for Jochen Gerz than central Paris's one black skyscraper, the Tour Montparnasse. Gerz's principle of mass participation, again crucial for the Coventry projects, started then. He sent about 800 plastic bags printed with the words "Is their life on Earth?", to friends, art galleries in Nice, Munich, London, Swansea, Belgrade, Basel, Montevideo and Buenos Aires (the artworld was already global) and to unknown people selected at random from the telephone book. He asked them to jettison their personal mementos: "So what is proposed here is to free you of whatever you want to get rid of." Finally on 16 April, 1970, 300 filled bags were buried in the foundations of the new building – 30 metres below street level, and covered with concrete five metres deep. The Montparnasse monolith (one thinks forward to Harbug) was erected over Gerz's 'signature act': a magnificent appropriation. These secrets that would never be revealed were time capsules contemporary with his *Burials* series; the inscriptions on *Public Bench* likewise, though mysterious names and dates in Coventry replace jettisoned material objects. Both require ultimately anonymous or 'lost' authors.[18]

A shift was definitively confirmed, then, in the 1960s: modern art's most powerful medium was to be the visual not the literary world. A sustained international network and market had been established, with its sacred sites, pilgrimages, festivals, and critical literature, far transcending the slim and untranslated volumes produced by the poetry editors of various nations, each jealous of the language of its tribe. "So little has changed since Joyce…. Literature is incapable of assimilating its writers" declared Gerz in 1975. "Dan Graham, André and Acconci are also former writers who do art now."[19] The conceptual art and performance movements, mail art and the explosion of photo pieces with texts were thus related to a global phenomenon of a literature which had nowhere to go, which was urgently seeking new audiences and a new public profile. And a new politics, at a moment when Roland Barthes' notion of the 'death of the author' conjoined with the egalitarian 'everyone is an author': Gerz's commitment to the uniqueness of each personal narrative is unwavering.[20] Compare the work involved in soliciting extraordinary stories of ordinary people commemorated on Coventry's *Public Bench*, described at length and with photos in the *Coventry Evening Telegraph*, with Gerz's action in the Intermedia festival in Basle in 1969. 5,000 cards were thrown off a roof in the town centre inscribed: "If you have found this card you are the missing part of the book I'm writing. Please pass the afternoon

Jochen Gerz, *2146 Stones: Monument against Racism*. Saarbrücken, 1993. Courtesy Courtauld Institute.

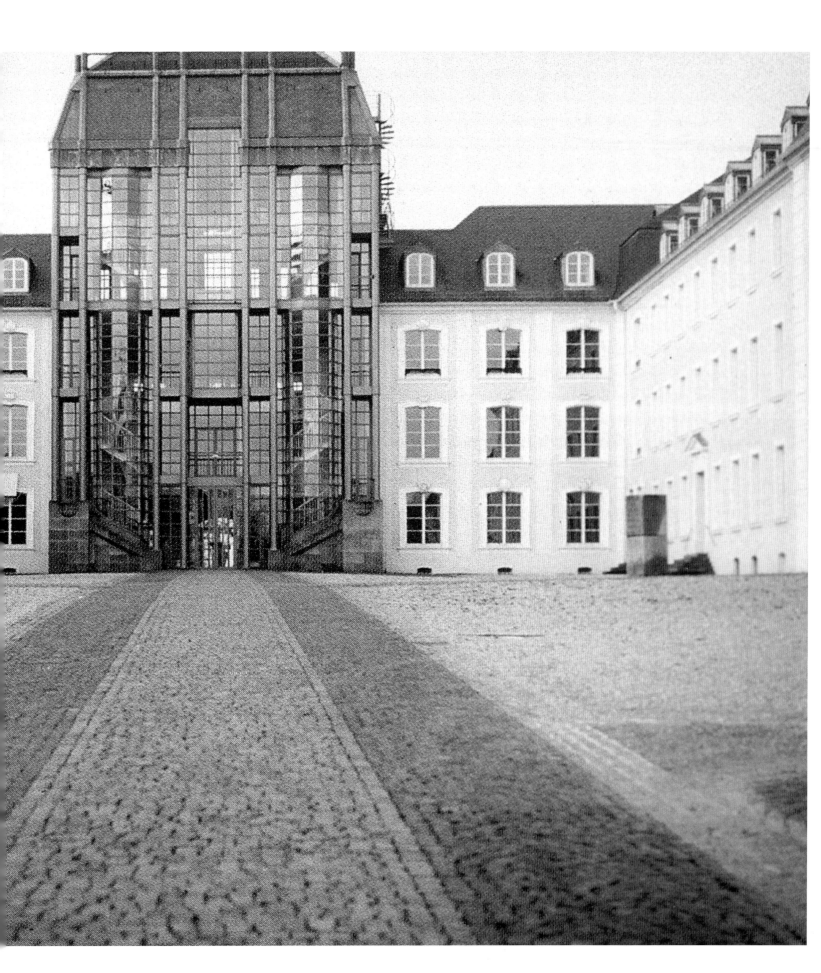

in Heidelberg as though nothing had happened and don't let your behaviour be influenced by this notice. Like this I'll be able to finish the book I'd like to dedicate to you."[21]

Already, however, there was a dark side to his work: the performance and photo piece where he led a blind man across a road several times, 1970, or the video of Gerz in a bare landscape shouting hoarsely: *To Cry until Exhaustion*, 1972. One day that year – on a sports-reporting mission for the '72 Olympics, he saw a sign to Dachau and followed it on his bike. His artist's life in Basel, London and Paris had managed to bypass direct confrontation with Germany's Nazi past. Now, on 3 September, 1972, he took 50 photos in the museum on the concentration camp site. The anodyne paraphernalia of the museum, signs, requests, prohibitions – above all the 'Exit' notice – became signifiers of unimaginable horror. The obscene neutrality of this signage, its 'innocence' implicated every visitor. His installation, *Exit. Materials for the Dachau project*, a 'staging' of his 'documentary evidence' created a scandal at ADA 2, the first Berlin Biennale in 1974: 20 tables and chairs set in two rows, 20 photo albums, 20 low wattage bare electric lightbulbs – with a tape of the breath of a person in flight and two electric typewriters....[22] This was another invitation to audience participation, to narratives imaginable and unimaginable. The piece was subsequently shown in Paris, where his contemporaries, writer Georges Perec and fellow-artist Christian Boltanski were starting – obliquely – to broach similar themes within the amnesiac, crisis-ridden period of the early 1970s.[23]

This is the man then, who was summoned to Coventry; a sculptor in the "extended field", its domains expanding to involve poetry (words), performance (time), photography (space), installation (institutions).[24] He is a contemporary, for example, of Britain's Richard Long; both artists, aged 36, represented their countries at the Venice Biennale of 1976.[25]

When Gerz presents his work to a new audience, it is, however, on the celebrated projects of the 1980s and 1990s that he depends, such as the *Harburg Monument against Fascism,* conceived and

executed with Esther Shalev-Gerz, and inaugurated in this Hamburg industrial suburb in 1986. A column clad in lead, 12 metres high, was designed to sink gradually until its complete disappearance in 1993. The public were invited to make a stand against facism by signing the lead surface. "We were surprised by the violence of the public... some people fired shots at the monument, others used knives, drills, even saws."[26] All too often, the anti-racist slogans *Tod dem Faschisten* or *Nazis Raus* evoked their dialectical other – the disturbing rise in racism during the decade.[27] Equally powerful was Gerz's *2146 Stones Monument against Racism* of 1993, generated by his encounter with inscriptions on the walls of a prison cell in the Saarbrücken castle, once home of the federal aristocracy, then Gestapo headquarters, now home to the regional parliament; it dominates the city. Working with students from the Saarbrücken Academy for the Visual Arts (as he did with both Chelsea School of Art and the Coventry University School of Art and Design for the Phoenix Initiative), Gerz replaced cobbles in the square with 'placebo stones', engraving the originals with the names of 2146 preserved or 'disappeared' Jewish cemeteries in Germany, prior to their replacement, just as they once were, chiselled-side down. A memorial that was invisible – disturbingly underfoot – initially a clandestine and illegal activity, finally containing 2146 moving secrets. Legalised, the renamed "Square of the Invisible Memorial" was inaugurated in 1993.

The first reaction to the presentation of a 'counter-monument' or a 'conceptual Holocaust monument' is one of astonishment.[28] (Violent reactions may follow later). The public is familiar with figurative triumphalism or pathos; religious and military imagery (the dying soldier as Pieta) or the abstract symbolism of the Cenotaph. In Europe, abstract versus figurative art debates were played out in war memorials and on concentration camp sites through the the 1950s and 60s, with their Cold War connotations of 'abstract-modernist-progressive' versus 'figurative-socialist realist-totalitarian'. Gerz and his generation called a halt. The collapse of the *grands récits* – the 'big stories' about national identity, patriotism, sacrifice, had implications more serious than arguments about form and representation.[29] "It is only when a thing is dissimulated that we

Jochen Gerz, *Monument vivant de Biron,* Dordogne, 1993-94. Courtesy Courtauld Institute.

insist upon its visibility as if it was due…" said Gerz.[30] Hence the 'open work'; hence invisibility, hence multiple potentials for interpretation.

The critical excitement generated around Gerz from the 1980s onwards, at a time when he was working with his Russian-born Israeli wife, Esther Shalev-Gerz, has been almost entirely linked to Holocaust studies – another 'expanded field' which, towards the millennium, emphasised the roles of memory within art and society; the relationship between memories repressed, recuperated or falsified; trauma and its psychoanalysis, and above all the uniqueness of individual testimony as generations passed forever. But to read the *Monument against fascism* as 'conceptual Holocaust memorial' – the consensus outside Germany – is far too limiting. The dark column, now completely invisible, was offered to the Harburg citizens precisely to record *their* signature against fascism, even if they 'recommissioned' it, exposing prejudices – and hatreds – over generations. The sunken stele, another time-capsule, is a record of their graffiti: the inscribed signatures together with abusive scribbled or spraypainted graffiti *are* the monument.

To read Gerz's work within the tragedy and pathos of the Holocaust framework alone avoids the question of his active participation in German intellectual life of the period of the *Historikerstreit* – the virulent and often painful debate on history and memory during the crucial periods before and after reunification.[31] As it avoids acknowledging his active participation in French intellectual life during this period; he continues to be an exile in Germany, resident in Paris. The re-exploration of France's continuing 'Vichy syndrome' has coincided with the trials of Klaus Barbie and Maurice Papon. These have generated responses not only by French artists and historians but by Gerz in projects such as the *The Witnesses of Cahors,* 1998, and for example, monumental works by Robert Morris.[32] The urgency of these debates in Europe have passed Britain by; as 'victor' nation we prefer to avoid intellectual debate and self-examination. Yet Gerz's work for Coventry is informed by this European experience both intellectually and formally. Take the *Monument vivant de Biron*: a German artist commissioned by the French state to refurbish

a French war memorial (Gerz, with the help of art students from Bordeaux, asked each of the 126 inhabitants of Biron a secret question: only their anonymous answers figure on the monument). This 'Living Monument' with its red plaques, then, was the spritual ancestor of Gerz's work for Coventry, even if the unrealised Manchester project offered the visual inspiration of obelisk and ground plaques for *Future Monument*.[33]

Memory brings us back to Coventry. As these questions have been debated, the questions of German pain and the 'inability to mourn' have at last resurfaced in Britain, notably in the writings of W G Sebald, a German academic in exile who chose to live here from 1970. His 1999 Zurich lectures, "On air, war and literature" published posthumously in English in 2003, reiterated again the almost unimaginable extent of the RAF's reprisal bombings of Germany: "1 million tons of bombs on enemy territory… 131 towns and cities attacked… about 600,000 German civilians fell victim to the air raids and 3.5 million homes were destroyed… 7.5 million left homeless… 31.1 cubic metres of rubble were produced for everyone in Cologne, and 42.8 cubic metres for every inhabitant of Dresden"; he discussed the historiography of both the documentation and amnesia of the periods of 'reconstruction'.[34] Beyond material history, he also examines the immaterial history: the rhetoric of war that corresponded to Coventry citizens' vision of pilots as "the pagan Hun"… "inhuman monsters", and afterwards, the silence.[35]

The silence of the generation of Gerz's parents, and burden of the German in exile in post war Europe was one that Gerz shared throughout the 1960s and beyond. His first silence robbed him of speech for a year, when, deafened by the blast, he watched his house in flames, trees that "fell so slowly and burned like candles"; his sister was lost.[36] "The most important factor in my life remains the war I did not fight…." For all of Gerz's work is autobiographical; the Phoenix project *par excellence*. Autobiographical from his first published work, in 1968, *Footing*, where into an exuberant babble of languages and phrase-fragments, typographical games and inserted signs, three aircraft appear, and the words "Bombers", red roofs, cry, sirens, North Sea, convoys, sacred duty, torpedos.[37]

It was Gerz himself who suggested the participation of a German theologian for a more developed book upon his work in English. As he grew up – indeed, he spent a year in a monstery with Cistercians and Gregorian chant – he would have been aware of Germany's new 'existential' theology. This attempted to reform religion for a shattered country of bombed churches, for bewildered populations who had nonethless been structured socially and mentally, as had their British counterparts, by the Judeo-Christian tradition.[37] That negativity and silence could be theorised helped. Interest in the concepts 'negative theology', the *deus absconditus*, the hidden God, have a long German tradition extending from the medieval Meister Eckhardt to post war German art history: Erwin Panofsky at Princeton, and the concept of the light-filled, 'salvational' cathedral. Gerz listened to theologian Karl Barth, along with Karl Jaspers while a student in Basel. Postmodern theologians today find in negative theology a bridge to 'deconstruction'.[39]

So much of Gerz's deconstructive project has involved notions of disappearance, blackness, unknowing, an allegorical groping in the dark: from his *Self Portrait*, of 1975 where he stood, writing backwards upon a pane of glass, till he obscured his image entirely, to his 1998 *Miami Islet*, an hommage to American conceptual artist Robert Smithson. Gerz invited the public to bring an empty bottle to the museum and hurl it against the wall in a blacked-out room. The act of throwing was invisible. Thermal imaging of the wall, the heap of glass, could in no way express the artist's intentions or the participant's experience: "I am engulfed in night... this protective space has turned into the invisible terrain of my own fears.... My steps become hesitant and, so it appears to me, echo with increasing volume in my groping blindness. Still no wall in sight... my ears are still ringing with the sound of smashing glass as if I had committed an inrrevocable deed.... But was my action in this place without significance?[40]

Invisibility; silence; absence; these may be interpreted in many ways: the dialectical affirmation of sacred presence, the silent witness of the dead, secrets of guilt – personal or national – betrayal, cruelty, Freudian repressed memory, 'poetic amnesia', theologically-inspired *Sprachskepsis*, absolute scepticism, or, in Gerz's case, "a concrete biographical fact which might be translated as a case of being " too late"."[41] Or indeed nothingness. As the tourist drives past Saarbrücken city square, unaware of cobblestones engraved with 'disappeared' Jewish cemeteries, there is no transmission of history, meaning or memory. The Coventry child of second generation immigrants runs obliviously over the plaques which might to another suggest the Norman Conquest, the Armada, the Cold War (French,

Spanish or Russian 'former enemies'). The response to *Future Monument* has already been humourous, cynical, irreverent.[42]

I would argue that the Coventry commission has offered an unusual gift to Jochen Gerz: the opportunity to make an intensely autobiographical work at a historic moment, this continuing period of the second Gulf War. The relentless bombing of civilian populations, of family homes, of children explodes everyday on our television screens – a diet of terror, sliced and interspersed with advertising and what Ezra Pound and then Jochen Gerz would call *kulchur*....[43]

Gerz follows his great predecessor Joseph Beuys as an artist-healer; for the public his sculptures, part of the regenerative Phoenix Initiative for Coventry, also invite a regeneration in people's minds. But the apparently innocuous, the 'engaging personality', the public face of the artist, hides the nocuous, the principles of innoculation. Gerz provokes, introducing notions of evil, enmity, loss and death; the dialectical others enshrined in the etymology of our languages: host and hostility, friend and fiend: *Feind,* the word for enemy in German, *Gift* the word for poison. Will we always be in a state of war in the twenty-first century? Jochen Gerz sees his works not only as a *Denkmal* – a contemplative monument, but a *Mahnmal*, a memorial containing the future as both warning and as promise. The translucent obelisk of *Future Monument* plays its part in the new millennial spectacle: a pillar of salt by day, a pillar of cold fire by night. But remember that obelisks in ancient Egypt came in twos, flanking either side of the temple. The obelisk has always a twin, a *Doppelgänger*, an invisible brother. Will the as yet unrealised second obelisk stand in Dresden, Hiroshima, Volgograd or Baghdad?[44] *Future Monument* is essentially a work of poetry in the memory theatre of Coventry's millennial projects. I insist again that, beyond the individual universes of personal secrets, Jochen Gerz works with the invisible, the unknowable, the unspeakable, haunted by the technological nightmare of the bomb which shadowed Coventry's neo-Romantic artists of the 1940s and the modernist optimists of its cathedral-building Cold War period; the technological nightmare of today.

NOTES

INTRODUCTION
RICHARD MACCORMAC AND VIVIEN LOVELL

1 Tess Jaray, National Garden Festival, Stoke-on-Trent, 1986; Tess Jaray, Centenary Square, Birmingham 1990; Paul de Monchaux, Oozell's Square, Birmingham 1992; Marta Pan's 'winning' design for Victoria Square, Birmingham, 1989.

2 Coventry University subsequently created international fellowships for artists Jochen Gerz and Françoise Schein, and their students were involved in both commissions. The University of Warwick offered Susanna Heron a solo exhibition, and also hosted a conference on the work of Jochen Gerz. David Morley, poet and Director of Creative Writing at Warwick, was appointed on our recommendation to be poet in residence during the project. His 'Phoenix Award New Writing' won the Arts Council's Raymond Williams Community Writing Award.

THE PHOENIX AND THE CITY: WAR, PEACE AND ARCHITECTURE
LOUISE CAMPBELL

1 *Resurgam*, RIBA, nd, c.1944.

2 Johnson-Marshall, P, "Coventry:Test-case of planning", *Listener*, 17 April 1958, pp.654-655.

3 See N, Tiratsoo, *Reconstruction, affluence and Labour politics: Coventry 1945-60*, London, 1990.

4 Pawley, M, "Coventry Cathedral", *Architects'Journal*, 9 May 1984, pp.48-53, provides a caustic critique of this trend.

5 *Birmingham Gazette*, 16 November 1940.

6 See L, Campbell, *Coventry Cathedral: art and architecture in post war Britain*, Oxford, 1996.

7 Spence was appointed architect in 1951; although the Upper Precinct was planned in the 1940s, it was not begun until 1951and completed in 1954.

8 See R T Howard, *Ruined and Rebuilt: the story of Coventry Cathedral 1939-62*, Coventry, 1962, and Basil Spence, Phoenix at Coventry, London, 1962, appendix A.

9 Collins, P, *Concrete: the vision of a new architecture*, London, 1959, p. 479, cites the vow made by the Greeks before the battle of Plataea in 479 BC.

10 Quoted Collins, p. 478.

11 I am indebted to the analysis in C van Eck's paper, *Piercing the Meaning of Form: an essay in architectural rhetoric*, paper for ACE Conference at the Architectural Association, 24 February 2001.

12 These panels, painted by Iri Maruki and Ioshio Akamatsu, were exhibited in St Mary's Hall, Coventry. See L Morris and R Radford, *The Story of the AIA 1933-53*, Oxford, 1983, p. 92.

13 See Johnson-Marshall, p. 654.

14 See Campbell, Chapter 2.

15 Gibson, D, "The Third Dimension in Town Planning", *Report of Proceedings at the Town and Country Planning Summer School*, 1947, p.103.

16 The Ljnbaan was completed in 1953, the Upper Precinct in 1954.

17 Wills, C, "Tomorrow comes to Coventry", *News Chronicle*, 10 June 1946. Gibson, D, "Reminiscences", manuscript notes, City Record Office, Coventry, 1972.

18 For a critical analysis, see P Hubbard, L Faire and K Lilley, "Memorials to modernity? Public art in the 'city of the future'", *Landscape Research*, vol. 28, no. 2, 2003, pp.147-169.

19 Mumford, L, "The Sky Line: Lady Godiva's Town", *The New Yorker*, 10 March 1962, p. 98.

A STRANGER WITH SECRETS: JOCHEN GERZ, FUTURE MONUMENT, PUBLIC BENCH
SARAH WILSON

1 "Public Art, Public Authorship" was the title of a symposium on Jochen Gerz's work at the Warwick Arts Centre, 29 November, 2003. See also *Third Text*, issue 71, vol. 18, no. 6, 2004, special issue on Art and collaboration, including "Toward Public Authorship", an interview between Jochen Gerz and Stephen Wright.

2 Gerard Groot, J, "Why did they do it?", *Times Higher Educational Supplement*, 16 October 1992, p.18, cited, with Churchill unsourced in W G Sebald, *On the Natural History of Destruction*, London: Hamish Hamilton, 2003, p. 19.

3 Gerz, Warwick Arts Centre, 29 November 2003.

4 Three mediaeval nails salvaged from the wreckage of the old cathedral, from the symbol of the Community of the Cross of Nails, an International Centre for Reconciliation of which there are 150 across the world.

5 The 'existential' humanist aspirations of Coventry, echoed in the works of a Francis Bacon or a Giacometti, were mirrored by Germany's own aspirations towards the reconstruction of a *Kulturnation* expressed by the *Menschenbild*. See *New Images of Man*, New York: Museum of Modern Art, 1959, prefaced by the German theologian-in-exile, Paul Tillich.

6 Ralph Beyer was the son of Oscar Beyer, author of a book on lettering in the Roman catacombs, *Die Katakombwelt, Grundriss. Ursprung und Idee der Kunst in der romischen Christengemeinde*, Tübingen, 1927. Ralph was trained at Chelsea and with Eric Gill; see Louise Campbell, *Coventry Cathedral. Art and Architecture in Postwar Britain*, Oxford: Clarendon Press, 1996, pp. 176-185.

7 See Fiona Scott, "Political sensitivity of city's Phoenix sculptures a worry", *Coventry Evening Telegraph*, 27 September 2001.

8 See Richard Gray, "On a Sense of Attention 1993" (relating to Ford Madox Brown's *Work* 1862-65) in *Jochen Gerz*, Nürnberg: Galerie Sima, 1993.

9 Two sketches, 13 August and 31 August, 1993, Atelier Gerz. See also the letter to Richard Gray, Manchester City Art Gallery, 13 August, 1993: "Voila the concept for the future Memorial proposal replacing the War memorial in St Peter's Square. The existing memorial would be kept, instead of the single "Italian contribution" would be placed in a quite similar way six marble plates all around the existing Memorial. This change would mark only the beginning of the new memorial since other Manchester communities contibutions could be added from this moment... the other project, the Long Bench (Piccadilly Gardens) has advanced too...." Manuscript additions include the words "Art School" and significantly "DRESDEN".

10 Andersen, Benedict, *Imagined Communities: Reflections on the Origin and Spread of Nationalism*, revised edition, London and New York: Verso, 1991.

11 "It is full of contradictions. I relate to the properties of glass in a personal way...." Gerz interviewed by the Student Project Group, Chelsea College of Art and Design, London, 2000.

12 Quoted by Jochen Gerz, inauguration speech, Coventry, 16 January, 2004.

13 Scott, Fiona, "Brother marks kindness of former enemy", *Coventry Evening Telegraph*, 28 February 2003. The Jochen Gerz archive has compiled a complete press dossier.

14 Ratushinskaya, Irina, "Lady Godiva", written in Labour camp ZhKh-385 near Barashevo, 300 miles south-east of Moscow, translated by Lyn Coffin with Sergei Shishkoff, in *Pencil Letter*, Newcastle-upon-Tyne: Bloodaxe Books, 1988, p. 42. See also Lucy Wilson, "Russian poet in Godiva city fame", *Coventry Evening Telegraph*, 11 September 2003, p.19.

15 For the best account of these years see *Jochen Gerz, Come on over to the dark side*, Lucerne: Kunstmuseum, 1979, which reproduces the Pound translation (Canto 99- unpaginated).

16 Gerz participated in *Total Theatre* at the Studio theatre and *Concrete Poetry* at the Royal Festival Hall, London in 1968, at the Edinburgh Festival and *Context*, Hatton Gallery, Newcastle-upon-Tyne in 1969, the Swansea Art Festival and *Three Towards Inifnity/Multiples* at the Whitechapel Art Gallery. London, 1970, and *Fuselarde* Zees Art Gallery, London 1971, small stops on an expanding international schedule.

17 *Attenzione l'arte corrompe,* in *Jochen Gerz. Performances, Installations and Works in Public* Spaces, Volker Rattemeyer and Renate Petzinger eds., Verlag für moderne Kunst, Nürnberg, and Museum Wiesbaden, 1999, catalogue raisonné, vol. 1, 1, p. 19. (See also vol. 2, *Texts and Mixed Media Photographs, 1969-1999*, 2000; vol. 3, *Editions and Photo/Texts (single works)* and vol. 4, *Works in Public Spaces II (1999-2004)*, 2004, for an idea of Gerz's vast output and bibliography.

18 *Is there life on earth?* Gerz catalogue raisonné vol. 1, 12, p. 24; for contemporary artworks see Jean-Marc Poinsot, *Mail Art*, Paris: Editions Cedic, 1971, and the *Fluxshoe* catalogue, Cullompton: Beau Geste Press, 1972; both include Gerz's pieces.

19 Gerz, Jochen, *Les Pièces*, Art/Cahier 1, Paris, 1975, interview with Suzanne Pagé and Bernard Ceysson, p. 4.

20 Significantly Barthes' "Le Mort de l'auteur" was first published in the experimental literary magazine *Mantéla*, V, 1968.

21 *The Book of Gestures,* 1969, Gerz catalogue raisonné vol. 1, 5, p. 21, (action repeated in Basel, 1969 and Frankfurt, 1972). Each red or blue card had the same number, 326 or 329 written on it – a red herring. For a lengthier literal translation see *326 Public piece*, 1969 in *Jochen Gerz People Speak*, Vancouver: Vancouver Art Gallery, 1994, pp. 32-33.

22 *Exit – Materialien zum Dachau-Projekt*, Hamburg: Edition Hossman, 1972; Jochen Gerz and Francis Lévy, *Exit – Materialien zum Dachau-Projekt*, Frankfurt: Verlag Roter Stern, Hamburg, 1974, and *Exit – Materialien sum Dachau-Projekt*, 1972/1974, Gerz catalogue raisonné vol. 1, 38, p. 38.

23 *Jochen Gerz, Les Pièces*, Art/Cahier 1, exhibition at the Musée d'Art Moderne de la Ville de Paris, 1975; compare the exhibition of Boltanksi's *Règles et Techniques* (1972) at the Galerie Ileana Sonnabend, Paris, 1975.

24 For reflections on Gerz, dialectics and time see Ulrich Krempel, "Timeless Time", in *Jochen Gerz*, Jouy-en-Josas, Fondation Cartier, 1988-89, pp. 138-140 (bilingual).

25 *Deutscher Pavillon: Beuys, Gerz, Ruthenbeck*, Venice Biennale, 1976.

26 Gerz, Jochen, interview with Jacqueline Lichtenstein and Gerard Wajcman (1993) in *2146 Stones, Memorial against Racism, Saarbrücken*, Stadtverband Saarbrücken, 1999, p. 7.

27 Thomas Wagner, visual arts editor of the *Frankfurter Allgemeine Zeitung* details the year-by-year rise of racist violence over the decade: "It is not the Artist who creates the Monument, or The Forked Path of Memory", in Jochen Gerz and Esther Shalev-Gerz, *The Harburger Monument against Fascism*, Kulturbehörde Hamburg: Verlag Hatje Cantz, 1994, pp. 93-114 (bilingual).

28 For the 'counter-monument' see James Young, *The Texture of Memory. Holocaust Memorials and Meaning*, New Haven and London: Yale University Press, 1993, and Young ed., *The Art of Memory. Holocaust Memorials in History*, New York: Jewish Museum, 1994.

29 I refer of course to Jean-François Lyotard's definition of postmodernism, translated as "an incredulity towards metanarratives" (*grands récits*) Significantly, Lyotard's first publication was a review of Karl Jaspers' *Die Schuldfrage (The Question of German Guilt*, 1946): "La culpabilité allemande", *L'Age nouveau*, 1948, 28, pp. 90-94.

30 Gerz's text upon illusion and visibility accompanies the piece *Self Portrait*, 1975, catalogue raisonné, vol. I, 45, p. 45, (English version of this text in Gerz's characteristic mirror-writing in *Jochen Gerz, Self-portrait*, the Geni Schreiber University Art Gallery, Tel Aviv University, 1995, pp. 33-34).

31 For the *Historikerstreit*, fired by Jürgen Habermas's challenge to Germany's conservative historians in 1986, see Peter Baldwin ed., *The Historikerstreit in context. Hitler, the Holocaust and the Historians' debate*, Boston: Beacon Press 1990; Daniel Goldhagen, *Hitler's Willing Executioners: Ordinary Germans and the Holocaust*, New York: Knopf, 1996; Finkelstein, Norman G, *The Holocaust Industry. Reflections on the Exploitation of Jewish Suffering*, London: Verso, 2000. The debate continues.

32 Gerz's *Les Témoins* interviewed 48 women of Maurice Papon's generation the week before his trial in 1998, making posters of their faces with their thoughts, posted in the village of Cahors – disseminated in newspapers *La Depêche de Midi*, and the German edition of *Le Monde diplomatique*. Compare his 'work' with that of Henry Rousso, (author of *The Vichy Syndrome*, 1987, Harvard University Press, 1991), who has examined the videotapes of the Barbie trial, 1987, and their retransmission, 2000, on French television. For Robert Morris's *White Nights,* an installation projecting film from the Centre d'Histoire de la Résistance et de la Déportation, Lyons, see *From Mnemosyne to Clio, 1998-1999-2000*, Musée d'Art contemporain, Lyon, Milan: Skira, 2000 and Philippe Dagen, *De Mémoires*, La Fresnoy, 2004.

33 See Jochen Gerz, *La Question Secrète. Le Monument vivant de Biron*, Arles: Actes Sud, 1996, and Rosanna Albertini, "Biron – the Living Monument". White Memory on Red Glaze, *Jochen Gerz, Res Publica, The Public Works*, 1968-1999, Museion/Museum for Modern Art, Bozen/Bolzano: Hatje Cantz Verlag, 1999, pp. 29-32.

34 Sebald, W G, 2003, p. 3. He mentions the book by Alexander and Margarete Mitscherlich, *Die Unfaehigkeit zu trauern*, (The inability to mourn), first published as early in 1967.

35 "… the 'Krieghunden' of the Reich strain at their leashes. Howling and barking to be loosed in order that they may satiate their lust for the blood of innocent human victims…. Do not fail to remember what the pagan Hun has done to us, to our city alone, merits more punishment than they can ever receive. Think of the bleeding starving, enslaved nations of Europe still being crushed beneath the heels of these inhuman monsters." Ernest Hobbs, *The Battle of the Three Spires. Impressions of a Blind Citizen*, Gloucester: the British Publishing Company Ltd., Coventry July 1942, pp. 5 and 26.

36 von Drathen, Doris, "Jochen Gerz: On being the prey of oneself", *Kulturchronik* 2, 1991, p. 18.

37 Gerz, Jochen, *Footing*, Paris: Approches-paperback, 1968, Giessen: Anabas Verlag, 1969, unpaginated.

38 Thanks to John-Paul Stonard, whose *Art and National Reconstruction in Germany, 1945-1955*, PhD University of London (forthcoming) contains a detailed discussion of religious life and sacred art exhibitions in post war Germany.

39 Thanks to my colleague, Paul Crossley, for an introduction to negative theology and its historiography in the works of Hans Sedlmayer, Otto von Simson and Erwin Panofsky. See in particular G Ward, *Barth, Derrida and the language of Theology*, Cambridge: Cambridge University Press, 1995; Rico Sneller's work on Derrida and negative theology, and Oliver Davies and Denys Turner ed., *Silence and the Word. Negative Theology and Incarnation*, Cambridge: Cambridge University Press, 2002.

40 von Drathen, Doris, "The Stranger within Oneself. Jochen Gerz, Miami Islet" , *Miami Islet. Interactive Strategies in the Work of Jochen Gerz*, Kunstmuseum's des Kantons Thurgau, 2000, p. 41 (bilingual). This elaborates on "Smithson's unrealised `Island for Broken Glass'", 1970.

41 Gerz on the 'power of absence' in *2146 Stones*, op. cit., p. 9.

42 Dyckhoff, Tom, "No-score draw for Coventry city", *The Times*, 30 December 2003.

43 See Gerz's *Kulchur Pieces, nos 1-9*, 1979-1984, which use Pound's 'multinational' appellation forged as early as 1912.

44 2004 marks the sixtieth anniversary of Coventry's twinning with Volgograd, formerly Stalingrad, the first ever twinning of cities.

COVENTRY'S 26 TWIN CITIES

1	ARNHEM	The Netherlands	1958
2	BELGRADE	Serbia	1957
3	BOLOGNA	Italy	1960
4	CAEN (Université de Caen)	France	1957
5	CORK	Eire	1960
6	CORNWALL	Ontario, Canada	1972
7	COVENTRY (Fire Association)	Connecticut, USA	1962
8	COVENTRY	New York, USA	1972
9	COVENTRY (Police Department)	Rhode Island, USA	1971
10	DRESDEN	Germany	1956
11	DUNAUJVAROS	Hungary	1962
12	GALATI	Romania	1062
13	GRANBY	Quebec, Canada	1963
14	GRAZ	Austria	1957
15	JINAN	People's Republic of China	1983
16	KECSKEMET	Hungary	1962
17	KIEL	Germany	1947
18	KINGSTON	Jamaica	1962
19	LIDICE	Czechoslovakia	1947
20	OSTRAVA	Czechoslovakia	1959
21	PARKES	New South Wales, Australia	1956
22	SAINT-ETIENNE	France	1955
23	SARAJEVO	Bosnia/Herzegovina	1957
24	VOLGOGRAD	Russia	1944
25	WARSAW	Poland	1957
26	WINDSOR	Ontario, Canada	1963

COVENTRY TIMELINE

	
1043	Earl Leofric and Godiva found St Mary's Benedictine Priory.
1086	Domesday Book reveals population of Coventry to be 350.
1102	Church at St Mary's Priory becomes Coventry's first Cathedral.
1300	Wool trade important in Coventry with non-fading Coventry Blue cloth (hence the phrase 'True as Coventry Blue').
1345	Coventry officially becomes a City when granted a Royal Charter of Incorporation by King Edward III. Coventry could now have its own Council which could elect its own Mayor.
1456	Royal Parliament held in Coventry reflecting its position as fourth biggest and most powerful city in England. Queen Margaret had moved her Royal Court to Coventry.
1539	St Mary's Cathedral destroyed in the Dissolution.
1569	Mary Queen of Scots imprisoned in St Mary's Hall.
1627	Silk weaving started in Coventry.
1648	During English Civil War St John's Church used as a prison for Royalist soldiers. It is said that the strongly Parliamentarian people of Coventry ostracised the prisoners and that is from here that the phrase "Sent to Coventry" originates.
1705	Ribbon weaving employed over 2,000 hand loom weavers.
1768	Work starts on the Coventry Canal, the initiator of Coventry's modern industrial age.
1801	Coventry's population at 16,000.
1832	Drapers' Hall opens (Architects: Rickman and Hutchinson).
1838	London to Birmingham Railway opens (Engineer: Robert Stephenson) linking Coventry to London by rail
1840	Cash's begin production of silk ribbons (company still survives a producer of woven labels).
1841	Author Mary Ann Evans better known as George Eliot moves to Coventry.
1850	Silk Ribbon Factory constructed (listed Grade II) – became a ragged school after collapse of silk weaving trade in 1860.
1850	Watch-making employs 2,000 in Coventry.
1851	Coventry's population at 37,000.
1856	Blue Coat School (Architect: James Murray) built on remains of the north west tower of St Mary's Benedictine Priory.
1860	Collapse of Ribbon trade, starving weavers and soup kitchens at St Mary's Hall.
1861	James Starley sets up factory to manufacture his revolutionary sewing machine.
1868	James Starley, 'father of the British Cycle industry' produces his first bicycle.
1870	Humber open factory in Coventry making bicycles. Coventry centre of bicycle manufacture industry.

Other firms include Premier Cycle Company, Bayliss and Thomas, Coventry Eagle, Rudge-Whitworth, Swift and Triumph.

	
1871	George Eliot's *Middlemarch* based on Coventry.
1884-85	Henry VIII Grammar School (Architect: Edward Burgess).
1887	Humber bicycle factories opened in Coventry.
1890	Pneumatic tyres start being made in Coventry.
1894	Alfred Herbert makes his machine tools company a Limited Company, it goes on to become world's largest machine tool manufacturer.
1896	Daimler Motor Company manufacture first car in Coventry, the birth of the British Car industry.
1901	Coventry population reaches 70,000.
1902	Triumph first produce motorbikes in Coventry.
1903	Standard Motor Company founded in Coventry.
1904	Rover produce first cars in Coventry.
1904	Cortaulds set up in Foleshill, Coventry – become one of leading man-made fibre company in world.
1907	Sir Frank Whittle, inventor of the jet engine, born in Coventry.
1911	Sinking of Coventry Colliery.
1911	Rudge-Whitworth manufacture first motorcycles.
1916	Electrical engineering companies GEC and British Thomson-Houston open factories in Coventry. Producing magnetos and other components for the car, aircraft, telephone and radio industries.
1918	St Michael's Parish Church becomes Coventry's second Cathedral.
1919	Carbodies coach building firm opens (still operating as London Taxi International).
1920	First Alvis car produced, based on designs by Geoffrey de Freville.
1920	Sir W G Armstrong-Whitworth's Aircraft Company starts making airplanes in Coventry.
1922	Coventry poet Philip Larkin born.
1928	Jaguar Cars (then Swallow Sidecar and Coach Building Company) move to Coventry.
1931	Gaumont Cinema opens.
1937	New Coventry Hippodrome Theatre opens (Architects: W S Hattrell and Partners).
1938	Hawker Siddeley Aircraft company based at Bagington formed (merger between Hawker Aircraft Company and Armstrong Siddeley Ltd).
1940	The Blitz. Biggest single air attack on British city during the Second World War. Original St Michaels Cathedral largely destroyed left as a burnt out shell.
1942-45	Lancaster bombers built at Bagington.

1946	'Little Grey' Ferguson tractors first produced by Standard Motor Company.
1948	First taxi produced by Carbodies (over 100,000 taxis have been produced in Coventry).
1948	The Queen (then Princess Elizabeth) visits Coventry to inaugurate the new Civic Scheme, introduced by City Architect Donald Gibson, it incorporates Europe's first traffic free shopping precinct.
1949	Godiva statue unveiled.
1949	Jet engine aircraft Meteors first made in Coventry by Hawker Siddeley.
1953	Woolworths, Market Way opened.
1954	Owen Owen Department Store opened (Architect: Rolf Helberg and Harris).
1955	Upper Precinct completed (Architect: Donald Gibson).
1955-65	Lanchester College of Technology, Cope Street (Architect: Arthur Ling).
1958	Standard sell tractor building interests to Massey Harris (later becomes important Coventry firm Massey Ferguson).
1958	Belgrade Theatre opens (Architect: Arthur Ling).
1958	Circular Market Hall opens.
1958	Lower Precinct completed (Architect: Arthur Ling).
1959-62	Station, Station Square (Architect: W R Headley).
1960	Herbert Art Gallery opens (Architect: Herbert, Son and Sawday).
1960	M6 to the north of Coventry opens.
1960	Locarno Dancehall, Smithford Way opens (becomes the Library in the 1980s).
1961	Coventry population over 300,000 (quadruple what it was at the start of the Century).
1962	Sir Basil Spence's Coventry Cathedral consecrated. (features Jacob Epstein's St Michael and Lucifer; Geoffrey Clarke's thorny abstract cross; Elizabeth Frink's lectern; stained glass by Lawrence Lee, Geoffrey Clarke and Keith New; tapestry by Graham Sutherland). Benjamin Britten's *War Requiem* written for the opening.
1965	University of Warwick opens in Coventry.
1967	Coventry City Football Club managed by Jimmy Hill are promoted to the First Division. They remain in the top flight until 2001.
1968	The Mini Cooper chase scenes in the film *The Italian Job* (supposedly beneath the streets of Turin) were actually filmed in a giant sewer pipe then being laid in Coventry.
1969	First Scorpion tank produced by Alvis.
1970	Peugeot acquires the bankrupt Rootes Group (incl. Hillman, Humber, Singer and Sunbeam) from Chrysler for $1.
1972	Coventry band Lieutenant Pigeon go to Number One with *Mouldy Old Dough*.
1973-74	Coventry Rugby Football Club win RFU Knockout cup two years in succession captained by David Duckham.
1974	Inner Ring Road completed – the first in the UK.
1976	M69 motorway opened linking Coventry to M1.
1979	Coventry record label 2-Tone Records founded by Jerry Dammers of The Specials.
1980	Severe slump in the city's economy – unemployment rises to over 20 per cent.
1980	Coventry band The Specials go to Number One with The Special AKA Live EP (*Too Much To Young*).
1981	Coventry band The Specials go to Number One with *Ghost Town*.
1982	Coventry athelete David Moorcroft breaks 5,000 metre World Record in Oslo.
1987	Coventry City Football Club win FA Cup final 3-2 against Spurs.
1987	Sir Frank Whittle Jet Engine Heritage Centre opens at Midland Air Museum, Bagington.
1989	Coventry Eastern ByPass (A46) opened – leading to development of Cross Point, Leofric and Binley Business Parks.
1990	Cathedral Lanes retail development opens.
1991	West Orchard Shopping Centre opens.
1991	M40 opens.
1992	Coventry Polytechnic awarded University status as Coventry University.
1996	Coventry celebrates the Centenary of the Motor Car – 100 years since the first British produced car was built in Coventry.
1997	Masterplan initiated by Coventry City Council.
1998	Jaguar Daimler Heritage Trust Collection opens.
2001	Priory Visitor Centre completed.
2003	Whittle Arch raised.
2003	Grand opening of Millennium Place and Priory Place.
2004	Coventry Transport Museum re-opens.
2004	Coventry Rugby Football Club play last game at Coundon Road – move to new stadium on site of their original 1880 ground at the Butts.
2005	Coventry City Football Club move to new £60 million stadium in Foleshill, the Jaguar Arena (Architects: RHWL).

SELECTED FURTHER READING

COVENTRY

McGrory, David, *A History of Coventry*,
Phillimore, 2003.
ISBN: 1860772641

Demidowicz, George, *Buildings of
Coventry: An Illustrated Architectural
History*, Tempus Publishing, 2003.
ISBN: 0752431153

Campbell, Louise, *Coventry Cathedral:
Art and Architecture in Post War Britain*,
Clarendon Press, 1996.
ISBN: 0198175191

Thoms, David and Donnelly, Tom,
The Coventry Motor Industry,
Ashgate, 2000.
ISBN: 0754601080

Kempster, Graham, *The City of Coventry*,
(Images of England Series), Tempus
Publishing, 2004.
ISBN: 0752433571

*A Jarrold Guide to the Historic City of
Coventry*, (with City Centre map and
illustrated walk), Jarrold, 2000.
ISBN: 0711716001

Douglas, Alton and Douglas, Jo,
Coventry: A Century of News, Brewin,
1995.
ISBN: 1858580552

Douglas, Alton. Coventry at war.
Brewin, 1992.
ISBN: 1858580048

Douglas, Alton, *Memories of Coventry:
A Pictorial Record*, Brewin, 1994.
ISBN: 1858580323

Smith, Albert and Fry, David, *Godiva's
Heritage: Coventry's Industry*, Simanda
Press, 1997.
ISBN: 0951386735

Smith, Albert and Fry, David, *Coventry
we have lost*, Simanda Press, 1995.
ISBN: 0951386719

Smith, Albert and Fry, David, *Coventry
we have lost*, (Volume 2), Simanda
Press, 1995.
ISBN: 0951386727

THE ARTISTS

ALEXANDER BELESCHENKO
Taylor, Louise and Lockhart, Andrew,
*Glass, light and space: new proposals
for the use of glass in architecture*,
Crafts Council, 1997.
ISBN: 1870145712

Beleschenko, Alexander, *Glass-
Interventions*, Deutsches
Glasmalerei-Museum Linnich, 2003.
ISBN: 3935019645

JACOB EPSTEIN
Rose, June, *A Life of
Jacob Epstein*, Baker & Taylor, 2002.
ISBN: 0786710004

Cork, Richard, *Jacob Epstein*,
Tate Publishing, 1999.
ISBN: 1854372823

JOCHEN GERZ
Gerz, Jochen, *Jochen Gerz, Res Publica,
The Public Works 1968-1999*, Hatje
Cantz, 1999.
ISBN: 3775708847

Deecke, Thomas, *Jochen Gerz Life after
Humanism*, Hatje Cantz, 1997.
ISBN: 3893224688

Gerz, Esther and Jochen,
Reasons to Smile, Acts Sud, 1997.
ISBN: 2742712771

Gerz, Jochen, *The Harburg
Monument Against Fascism*,
Verlag Gerd Hatje, 1994.
ISBN: 3775704981

SUSANNA HERON
Heron, Susanna, *Stills from Sculpture*,
Abson, 1999.
ISBN: 0952036517

Heron, Susanna, *Elements*, Mead
Gallery and Warwick Arts Centre, 2003.
ISBN: 0902683648

Heron, Susanna, *Shima: Island and
Garden*, Abson, 1992.
ISBN: 0952036509

DAVID MORLEY
Morley, David, Scientific Papers,
Carcanet Poetry, 2002.
ISBN: 1857545672

Morley, David, *Ludus Coventriae*,
Prest Roots Press, 2002.
ISBN: 187123722X

Morley, David, *Phoenix New Writing*,
The Heaventree Press, 2003.
ISBN: 0954531701

JOHN PIPER
West, Anthony, *John Piper*,
Secker & Warburg, 1979.
ISBN: 0436565900

Piper, John. John Piper : the complete
graphic works. Faber, 1987.
ISBN: 0571149901

FRANÇOISE SCHEIN
Schein, Françoise, *Les Paris/Paris*,
Paris-Musees, 1991.
ISBN: 2909139026

BASIL SPENCE
Spence, Basil, *Phoenix at Coventry:
The building of a cathedral*, Collins, 1963.

Spence, Basil, *Out of the ashes: A
progress through Coventry Cathedral*,
Bles, 1963.

Edwards, Brian, *Basil Spence, 1907-
1976*, The Rutland Press, 1995.

GRAHAM SUTHERLAND
Hayes, John, *Art of Graham Sutherland*,
Phaidon Press, 1980.
ISBN: 0714820350

Sutherland, Graham, *Graham
Sutherland: complete graphic work*,
Thames and Hudson, 1978.

DAVID WARD
Ward, David, *Canopy*, Harvard University
Art Museums, 1997.
ISBN: 0916724948

KATE WHITEFORD
Whiteford, Kate, *Archaeological
Shadows*, Mount Stuart Trust, 2003.
ISBN: 0954474805

Whiteford, Kate, *An Leabhar Mòr – The
Great Book of Gaelic. An international
celebration of contemporary Celtic
culture*, 2002-2004.

ARCHITECTURE

Jackson, Nicola, *Building Ideas: The Architecture of MacCormac Jamieson Prichard*, Wordsearch, 2005.

Cruikshank, Dan, *Architecture: The Critics Choice (150 Masterpieces Selected and Defined by the Experts)*, Aurum Press, 2000.
ISBN: 1854107208

Watkin, David, *A History of Western Architecture* (3rd ed.), Laurence King, 2004.
ISBN: 185669223X

Pearman, Hugh, *Contemporary World Architecture*, Phaidon, 1998.
ISBN: 0714842036

URBAN PLANNING

Rowe, Colin and Koetter, Fred, *Collage City*, MIT Press, 1984.
ISBN: 0262680424

Sitte, Camillo, T*he Birth of Modern City Planning*, eds., Collins, George R and Crasemann, Christiane, Rizzoli, 1986.
ISBN: 0847805565

English Partnerships and the Housing Corporation, *The Urban Design Compendium*, Llewelyn-Davies, 2000.

REGENERATION

Department for Culture, Media and Sport, *Culture at the heart of regeneration* – consultation paper, DCMS, June 2004.

Evans, Graeme and Shaw, Phyllida, *The Contribution of culture to regeneration in the UK: a review of evidence. A report to the Department for Culture Media and Sport*, London Metropolitan University, January 2004.

Roberts, Peter and Sykes, Hugh, *Urban regeneration: a handbook*, British Urban Regeneration Association/SAGE, 2000.
ISBN: 0761967176

Couch, Chris et al, *Urban regeneration in Europe*, Blackwell Science, 2003.
ISBN: 0632058412

LANDSCAPE

Bell, Simon, *Elements of visual design in the landscape*, (2nd ed.), Spon, 2004.
ISBN: 0415325188

Dorrian, Mark and Gillian Rose, *Landscapes and Politics*, Black Dog Publishing, 2003.
ISBN: 1901033937

Dee, Catherine, *Form and fabric in landscape architecture: a visual introduction*, Spon, 2001.
ISBN: 0415246385

Holden, Robert, *New landscape design*, King, 2003.
ISBN: 1856692906

Spens, Michael, *Modern landscape*, Phaidon, 2003.
ISBN: 0714841552

PUBLIC ART

Public:Art:Space: a decade of Public Art Commissions Agency, 1987-1997, Merrell Holberton, 1998.
ISBN: 1858940486

Re Views: Artists and Public Space, Thomas Heatherwick, Chris Murray, et al, Black Dog Publishing, 2005.
ISBN: 190477220X

Arts Council Southern and South East Arts, *Art at the Centre: City and town Centre Initiative*, Arts Council, 2002
http://www.artscouncil.org.uk/information/publication_detail.php?browse=recent&id=130

Arts Council, *Commissioning Art Works*, Arts Council, 1996.
ISBN: 0728707179
http://www.artscouncil.org.uk/documents/publications/1004.pdf

Burton, R (Chair), *Percent for Art: Report of a steering group*, Arts Council, 1990.

Cork, Richard, *A Place for Art*, Art Development Trust, 1993.

Darke, Johanna, *A User's guide to public sculpture*, English Heritage, 2000.
ISBN: 1850747768

English Heritage, *Monuments and the Millennium*, James and James Ltd, 1998.
ISBN: 1873936974

Kochs, W, Owens, P and Salvadon, D, *The Arts and the Changing City – An Agenda for Urban Regeneration*, British American Arts Association, 1989.

Michalski, Sergiusz, *Public Monuments – Art in Political Bondage 1870-1997*, Reaktion Books, 1998.
ISBN: 1861890257

Miles, Malcolm, *Art, space and the city: public art and urban futures*, Routledge, 1997.
ISBN: 0415139430

Powell, Robert and Stephenson, Nicola, *Making places: working with art in the public realm*, Public Arts, 2001.
ISBN: 0954074807

Roberts, M, Marsh, C and Salter, M, *Public Art in Private Places*, University of Westminster Press, 1993.
ISBN: 1859190200

Rosenberg, Eugene and Cork, Richard, *Architect's Choice: Art in Architecture in Great Britain Since 1945*, Thames and Hudson, 1992.
ISBN: 0500276587

COVENTRY WEBSITES :
Coventry City Council -
http://www.coventry.gov.uk
Visit Coventry -
http://www.visitcoventry.co.uk
ICCoventry (produced by Coventry Newspapers) -
http://iccoventry.icnetwork.co.uk
CWN (Coventry & Warwickshire's largest independent website) -
http://www.cwn.org.uk/
Coventry Web -
http://www.coventryweb.co.uk
David Fry's 'Coventry we have lost' website - http://freespace.virgin.net/d.fry/

PHOENIX INITIATIVE RELATED WEBSITES
MacCormac Jamieson Prichard –
http://www.mjparchitects.co.uk

Rummey Design Associates -
http://www.rummey.co.uk/

Modus Operandi Art Consultants -
http://www.modusoperandi-art.com
Jochen Gerz: http://www.gerz.fr/
Susanna Heron:
http://www.susannaheron.com

Warwick Magazine -
http://www2.warwick.ac.uk/about/warwickmagazine04/publicart/
Public Art Online -
http://www.publicartonline.org.uk/case/coventry_phoenix/description.html

COVENTRY WALKS
Coventry's Historic Heart: a walking tour, (£1.00 plus P&P)
available from Tourist Information Centre on Bayley Lane, Coventry.
tel: 44 024 7622 7264

Coventry City Centre Trail guide booklet, (£1.00 plus P&P)
available from Tourist Information Centre on Bayley Lane, Coventry.
tel: 44 024 7622 7264

Illustrated walk in Jarrold Guide to the Historic City of Coventry, (£2.50 plus P&P)
available from Tourist Information Centre on Bayley Lane, Coventry.
tel: 44 024 7622 7264

Five and half miles of art: Coventry Canal Basin Public Art Trail,
Available from Coventry City Council Planning.
tel: 44 024 7683 1212

PHOENIX INITIATIVE COVENTRY
ACKNOWLEDGEMENTS

The contributors would like to thank all those in Coventry who made this project possible. John Fletcher who as leader of the Council at the inception of the Phoenix Initiative, and chairman of the Millennium Forum throughout the project, displayed an inspirational commitment to Coventry and the role that the Phoenix project could play in the Coventry's future. All the members of the Millennium Forum who willingly gave time and energy to make the difficult decisions needed to keep the project on track and ensure that it represented the interests of the whole community. The various leaders of the council and cabinet members who have maintained faith throughout the project. John McGuigan and Andy Telford who got the project off the ground, and Chris Beck, Colin Dale and Susanne Smith from the Phoenix Project Office who devoted seven years to deliver the project for the city. George Demidowicz and Margaret Rylatt who worked tirelessly to unearth and preserve the archaeology on the site, working within the restrictions imposed by the construction process. Others who we would like to thank who have made invaluable contributions throughout this project include Barry Littlewood of the Coventry Transport Museum, Duncan Elliott who lead the difficult process of site acquisition, Peter Collard of CV1, Ian Prowse from the planning department. Thanks are due to Professor Clive Richards, Jill Journeaux and students from the University of Coventry School of Art and Design; also to Rachel Bradley of PACA.

We would also like to recognise the contribution of Ian Harrabin and John Moss of Complex Development Projects who, as developers of the Ribbon Factory and the city's partners on Priory Place and Millennium View, have played an essential role in realising the ambitions of the Phoenix and maintaining a commitment to quality that underpins the whole project. We would like to record our thanks to the other stakeholders who, through financial support or providing land to the project, shared our faith in the project and allowed the Phoenix to be realised:

The Millennium Commission
The Heritage Lottery Fund
Advantage West Midlands
Holy Trinity Church
Coventry Cathedral
ERDF
The Henry Moore Foundation
PRISM
DCF(Designation Challenge Fund)

The publication of PHOENIX ARCHITECTURE/ART/REGENERATION has been made possible given the generous support of the following:
Coventry City Council: www.coventry.gov.uk
Complex Development Projects:
www.complexdevelopmentprojects.co.uk
Balfour Beatty: www.balfourbeatty.com
MacCormac Jamieson Prichard: www.mjparchitects.co.uk
Rummey Design Associates: www.rummey.co.uk
Modus Operandi: www.modusoperandi-art.com
Speirs and Major: www.lightarch.com
Ashgate Development Services: www.ashgate.net
PCPT Architects: www.pcptarchitects.co.uk
Michael Popper Associates: www.michaelpopper.com

DESIGN TEAM

A complex project such as the Phoenix requires the creativity and skills of many organisations and individuals. There is not space to list all those individuals who contributed to the project, but the contributors would like to thank all involved for their involvement.

CLIENTS

Phoenix Initiative City of Coventry
Ribbon Factory, Priory Place and Millennium View Complex Development Projects

PHOENIX DESIGN TEAM

Master Planners and Architects MacCormac Jamieson Prichard
Art Consultant Modus Operandi (initially PACA)
Landscape Architects and Urban Designers Rummey Design Associates
Lighting Designers Speirs and Major
Project Manager Ashgate Development Management Services
Transport and Civil Engineers The Babtie Group
Cost Consultants W T Partnership

PHOENIX PHASE 1

Priory Garden, Priory Cloister, the Visitors' Centre and Garden of International Freindship
Artists Chris Browne, David Ward, Kate Whiteford, David Morley
Structural Engineers Babtie London
M and E Engineer Michael Popper Associates
Contractor Balfour Beatty
Priory Visitors' Centre Fit Out Past Forward

Blue Coat School
Architect Brownhill Hayward Brown
Structural Engineer Couch Consulting Engineers
M and E Engineer Greenway and Partners
Contractor John Harris and Sons of Stratford Ltd

PHOENIX PHASE 2

Developer Complex Development Projects
Project Manager Gardiner and Theobald Management Services
Artist Susanna Heron
Architects, Urban Designers and Landscape Architects MacCormac Jamieson Prichard
Executive Architects PCPT Architects
Structural Engineers Babtie London
M and E Engineer D W Pointer and Partners
Contractor Balfour Beatty

Ribbon Factory
Developer Complex Development Projects
Architects PCPT
Engineers Geoffrey Collett Associates
Cost Consultants Atkins F and G
Contractor Harrabin Construction Limited

Youell House
Architects MacCormac Jamieson Prichard
Executive Architects Coventry City Council
Structural Engineers Barneveld Consultants
Fit-out Architects Acanthus Clews Architects
Fit-out M and E Engineers Hulley and Kirkwood Consulting Engineers Ltd
Contractors Galliford Try Construction

Priory Undercroft
Architects Brownhill Hayward Brown
Quantity Surveyors Davidson Partnership
M and E Engineers AVUS Consulting Ltd
Structural Engineers Barneveld Consultants
Contractor John Harris and Sons of Stratford Ltd
Interpretation and Display fit-out Bremner and Orr Design Consultants Ltd

PHOENIX PHASE 3

Millennium Place and Coventry Transport Museum
Artists Françoise Schein
 Jochen Gerz
Structural Engineers Dewhurst MacFarlane and Partners
M and E Engineers Michael Popper Associates
Contractor Butterley Construction Limited

Bridge and Arch
Artist (Bridge) Alex Beleschenko
Structural Engineers Whitbybird
Contractors Butterley Construction (Main Contractor), Rowecord Engineering (Bridge Steel),
Ide Contracting with Mayers of Munich (Bridge Glass), Westbury Structures (Arch)

PHOENIX PHASE 4

Millennium Point (pending)
Developer Complex Development Projects
Architects Brimelow McSweeney Architects
Structural Engineer John Nolan Associates
Cost Consultant Walfords
M and E Engineer D W Pointer and Partners
Art Consultant SWPA Ltd

PHOENIX ARCHITECTURE/ART/REGENERATION

Designed by Studio Myerscough

■■■ Architecture Art Design Fashion History
 Photography Theory and Things

Black Dog Publishing Limited
Unit 4.4 Tea Building
56 Shoreditch High Street
London E1 6JJ

Tel: +44 (0)20 7613 1922
Fax: +44 (0)20 7613 1944
Email: info@bdp.demon.co.uk
www.bdpworld.com